A Window Back

Nicholas Whitman

6/15/94

Cataloging Data

Whitman, Nicholas, 1954–
A Window Back: Photography in a Whaling Port, by Nicholas Whitman
176 pp., illus., 23 cm.
1. New Bedford (Mass.)—History—Pictorial Works
2. Photography—Massachusetts—History
3. Whaling—New England—Photographers

History of photography in the New Bedford area between 1845 and 1920.
Illustrates the transformation of an old New England town into an industrial city.
Photographers sail aboard whaling voyages; visit other ports, live among Eskimos.
Also, regattas, waterfront trades, architecture, mills, Old Dartmouth township;
complete index and brief biographies of all local photographers during the period.

Book Design & Production: Joseph D. Thomas, John K. Robson, Nicholas Whitman

L.C. Catalogue Number: 93-86989
ISBN: 0932027-164 cloth
ISBN: 0932027-180 paper

Printed in the United States of America

Published by Spinner Publications Inc.
First Printing, © 1994

A Window Back

Photography in a Whaling Port

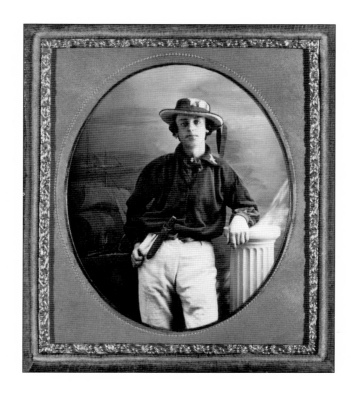

Nicholas Whitman

Foreword

A Window Back is a delightful and informative treasure of old photographs from the days of historic New Bedford. Its creator, Nicholas Whitman, is a competent and thoughtful photographer who learned his craft at the Rochester Institute of Technology and came to New Bedford dreaming about author Melville's *Moby Dick*.

When I met Nick, he had just taken a temporary project at the New Bedford Whaling Museum. However, the scope of his work gradually lengthened into the establishment of an excellent photographic laboratory, safe storage for negatives and prints, and a filing system that greatly improved the accessibility of the museum's priceless collection.

I was looking for photographs to enhance a nautical book that I was writing. On behalf of the museum, Nick not only found me ideal photographs but furnished me with beautiful prints of them. In addition, he made new negatives of several of my own photos so that both the museum and I could have revitalized copies. Thanks to Nick, my initial narrow interest grew into an appreciation of photographic collections and of the urgency to complete them before the demise of folks who might help to identify prints or search through their attics for fading and forgotten photographs.

As Nick organized the museum's photographs and added to the collection, the advantages of putting together a photographic book with a local focus became increasingly apparent. Such a book could give a firsthand look at New Bedford as seen through the eyes of those who lived in the nineteenth and early twentieth centuries.

I feel confident that *A Window Back* will inspire others to search out, organize, and identify their own photographic collections, ones which will be of great interest and importance to current generations and those yet to come.

– Waldo Howland

Acknowledgments

From the day I first encountered the photographic collections at the Old Dartmouth Historical Society, I knew this book needed to be done. Since that day, more than 15 years ago, support for the project has come in many forms, from many quarters.

For their help in building my Photographers Biographic Checklist, I am indebted to Mary Jean Blasdale, Paul Cyr, Carole Foster, Nancy Plante, and Gail Scott Sleeman. Support was also generously offered by my former colleagues at the Old Dartmouth Historical Society's Whaling Museum. I am grateful to them all, especially Virginia Adams, Dr. John R. Bockstoce, Elton W. Hall, Ed Hurley, Richard Kugler, Ken Okolski, the late Philip Purrington and Alton Bailey. Also, thanks to Thomas Adams, Richard Benson, former New Bedford mayor John Bullard and David Raymond for their helpful advice.

Special thanks go to Waldo Howland, who saw the worth of our efforts, encouraged others to contribute resources and imagery, and reviewed vintage negatives and prints, adding invaluable information.

I want to thank Anthony M. Zane, director of the New Bedford Whaling Museum, and the trustees of the Old Dartmouth Historical Society for permission to use photographs; the New Bedford Arts Lottery Council, the Polaroid Foundation, the Crapo Foundation and the Massachusetts Cultural Council for their substantial grant support; Joseph Thomas, John Robson, Pamela Sabean, Ruth Caswell, Emily Hodgson, Clara Stites and the staff at Spinner Publications for design and production.

Finally, to my wife Mary E. Natalizia, who was there every bit of the way, I dedicate this book.

– Nicholas Whitman

The photographs in this book have been selected from the holdings of the Old Dartmouth Historical Society, which owns and operates the New Bedford Whaling Museum. For further information about subject matter or photographers, inquiries should be addressed directly to the Museum.

– Trustees of the Old Dartmouth Historical Society

Contents

Photographs, like other works of art on paper, come in many different sizes, tones, and values. They are produced using different processes, giving each a unique look. The original image also provides important source information for research.

In the second line of the caption title, at right, a description of the original process type is given. If, for example, the print used for reproduction was made from a wet plate negative, then the negative is identified as the original process type. If a vintage print was the basis for what has been reproduced, then the print would be described.

Stereographs are not reproduced as double images on a card, but as single images. Seen in a viewer, the two images of a stereograph merge to form a single, three dimensional image—a quality these reproductions cannot convey.

The reader is urged to seek out original photographs to view first hand. Take the time to put a stereo card in a viewer and experience virtual reality, nineteenth century style.

Archives holding historical photographs include those of the New Bedford Whaling Museum, New Bedford Free Public Library, Spinner Publications and area historical societies.

The Photographic Record

~

As the city of New Bedford, Massachusetts grew, it changed. So did the way in which its people earned a living, passed a summer afternoon, or recorded a family history. The photographs in this book record moments of the city's history between 1841 and 1920 during the formative years of photography.

But an illustrated history is not the intent of this book, nor is such a history possible. Too many significant subjects simply were not photographed. Because early cameras functioned best in controlled studio settings, many of the photographs are formal portraits or, as techniques developed, sunlit views of ships, city streets, and buildings.

The dark interiors of mills and factories were difficult to photograph and are scantily represented in early pictures. Technical problems were compounded by a reluctance on the part of mill owners to have working conditions recorded. Even in the 1920s, when more than 40,000 people worked in New Bedford's textile mills, relatively few photographs were made to document the workplace.

Of the photographs included here, some are old favorites repeatedly sought for publication or personal enjoyment. The majority, however, have never before been published. The selection draws from more than 20,000 photographs in the archives of New Bedford's Whaling Museum, suggesting the richness and diversity of photography practiced in the greater New Bedford area. Each photograph records a moment of time, an angle of light, an expression or gesture. Considered together, these brief glimpses illuminate the past, giving us a window back through time.

With the introduction of photography in 1839, people discovered a new way of looking at the world. Photography froze time, capturing a single instant. The simple portrait of a child in a white dress could be created, treasured, and passed down generation after generation, making the past visible and history more tangible.

Photography was warmly received, and modestly priced daguerreotypes quickly won public favor. Although the velvet-encased daguerreotype has been replaced by do it yourself point and shoot photos, portraiture remains photography's most universal application.

In July of 1841, New Bedford's residents had their first opportunity to be photographed when O'Brien and Faxon, itinerant photographers, opened a temporary studio at Seven Cheapside, now Purchase Street. This type of studio was common in communities too small to support a full time studio. However, within one month, O'Brien and Faxon faced competition from town resident Philander Bryant.

By 1849 five studios competed for business, and by 1856 there were fifteen studios downtown. With competition brisk, advertisements in an 1859 *Evening Standard* offered imported cases and

superior workmanship. Although fancy cases added nothing to the quality of the image, they were important in marketing the package.

Fierce price wars fought on the front pages of the newspaper urged city residents to come for sittings. With price cutting, quality declined and quantity increased. The photographer with high standards was often forced out of business while the more competitive studios became portrait factories. Soon, everyone from infants to whaling masters was photographed.

Portraiture could be carried out only in the controlled environment of the studio. Acceptable results demanded skillful use of natural light from skylights, careful arrangement of backgrounds, and consistent subject-to-lens distance. The

technological limitations of the daguerreotype, the ambrotype or the wet plate negative required that the subject remain motionless for several seconds to keep from blurring the exposure. It was the photographer's task to direct a sitter's gaze and put the subject at ease. Portraits made under these carefully controlled conditions varied little, the pose stiffly held, the face unsmiling.

Technical considerations shaped the appearance of a photograph, but public attitude also played its part, making portraits anything but a casual matter. Women wore their Sunday dresses, gentlemen their best suits. Now everyone in New Bedford—sailors, whaling masters, merchants or mill workers—could have their likenesses recorded. Considerably less expensive than oil portraits and not prone

As the number of studios increased, price wars were waged by competing artists. This advertisement appeared in the New Bedford City Directory.

THE CHEAPEST PLACE IN THE CITY TO GET PICTURES, IS AT NYES' PHOTOGRAPH & FERROTYPE ROOMS, Opposite the City Clock, New Bedford.

to distortion by the artist's hand, photography was a truly democratic medium.

By 1880 the sitter's appearance grew less important while the atmosphere of the photograph took on new significance. Foreground props, sleighs, wagons, dolls, tree stumps and rocks, were combined with backdrops of landscapes, seascapes, snow scenes, and huge painted urns of flowers. Photography's role grew to include the creation of illusion.

With portrait in hand, the pleased sitter leaving the daguerreotype studio could have had no idea that 140 years later we would be considering his likeness. His image frozen in the silvered plate endures as a small claim to immortality after all who knew him and all the memories of him have ceased. In fact, no one in the

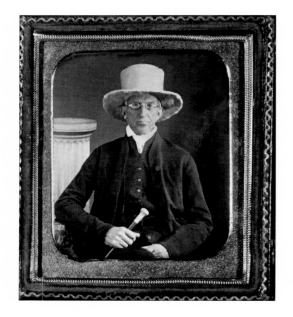

1840s could have foreseen the ways in which time would heap layers of meaning onto photographs. In those years, the photograph itself was more extraordinary than the subject, which was simply a part of the day's routine. City views taken in the early 1900s show streets full of horse-drawn wagons, not an automobile in sight. Time slips by, the ordinary shifts, and today we view the picture as unusual. Photography refines our perception, arresting appearances and allowing us to reconsider. It provides undeniable evidence of the changes which shape our world but are imperceptible from one moment to the next.

The daguerreotype, invented in 1837, was the first of many "types" of photography. This ⅙ plate daguerreotype of a Quaker gentleman was made around 1845.

Although portraiture monopolized photography for the first twenty years, by 1860 a handful of professionals had begun making exterior views. As with early portraiture, limitations of the medium were significant, demanding ingenuity and perseverance to secure successful results. But what results they were! At last the photographic documentation of the city, the countryside, and the harbor had begun.

At first, few exterior daguerreotype views of New Bedford were made because the daguerreotype process was not easily worked outside the studio. As technology advanced, the range of subjects grew. When the wet collodion negative, or wet

plate, was developed around 1869, multiple paper prints could be made from one image. Only then was exterior photography viable for the professional.

Even with the wet collodion negative, long exposure times still restricted photographers to stationary subjects. Also, the emulsion was excessively sensitive to blue light and rendered all skies cloudless and blank. Cameras had to be mounted on tripods and plates prepared just prior to exposure, requiring portable darkrooms on location. From these tight confines emerged photographs depicting buildings, moored vessels, fire apparatus, and an occasional street view.

Some of the earliest exterior photography was done by the Bierstadt brothers, who used 14" x 17" glass plates to produce prints of the same dimensions.

With no system for making enlargements, a large picture required a large negative. Expensive and unwieldy, large wet plates never became popular. Fewer than fifty of the Bierstadts' exterior photographs survive.

Instead of the large photograph, the tiniest form of wet plate view, the three-dimensional stereograph, became a 19th century favorite. To create a stereograph, photographers used a double-lensed camera, the lenses spaced apart at approximately the same distance as a person's eyes. This method created two slightly different perspectives that, when viewed through a stereoscope, merged into one magnified three-dimensional image. Like the daguerreotype portrait, the stereograph became a fad. In New Bedford, the fad rose like a wave in the 1860s, crested in the early 1870s, then broke and faded to nothing by the end of the decade.

In the heyday of the stereograph, New Bedford boasted several photographers of national repute including Stephen F. Adams, Charles and Edward Bierstadt, and Thomas E. M. White. From their hundreds of card-mounted views of the city comes a strikingly detailed record. These photographers sought out revealing vantage points, including dramatic bird's-eye views from the top of buildings. Even within the restrictions of the wet plate medium, they consistently produced carefully crafted, high-quality photographs.

Liberty Hall, burned out, was typical of the static subject matter the Bierstadt Brothers were limited to with their 14" x 17" wet plate camera.

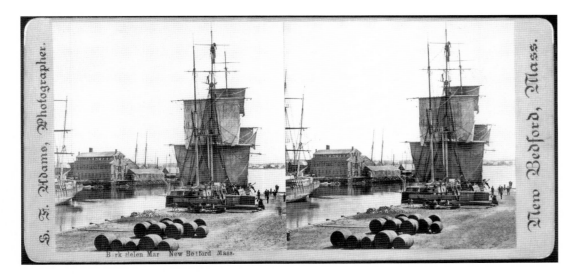

Bark Helen Mar, New Bedford, Mass.

New Bedford stereographs often featured the waterfront. Some became serialized and were marketed throughout the country.

Stereographs also meant that New Bedford people could be photographed outside of the studio, in their own environment. Stereographs became documentary records rich in detail, painstakingly considered for vantage point, systematically organized in coherent series, and created by people who knew the community and were well suited to immortalize it in silver.

A limited number of conventional two-dimensional photographs were made from stereographs by experienced professionals capable of mastering the complex process. These photographs were produced with the intent to sell. Most were commissioned or presented subjects of general interest.

In 1880 the gelatin dry plate became widely available. While still requiring a tripod and other bulky equipment, the dry plate greatly eased the photographer's burden. Dry plates were sold in light-tight boxes, ready to use, and required no field processing. This innovation gave birth to a new photographer with a new point of view—the amateur.

Amateur photographers made photographs of things they cared about. Clifford Baylies, a city engineer, photographed in detail the reconstruction of the bridge that linked New Bedford with Fairhaven. Artist Clement Nye Swift used his photographs of the countryside to help compose his paintings. James Allen, an avid yachtsman, photographed boats racing in New Bedford harbor.

With no one to answer to, the amateur was free to take chances and to make technical mistakes. As a result, amateur photography is often more interesting than that of the professional.

From 1880 on, there was a marked decline in the volume of professional field work as more people became familiar with cameras. Then, in 1889, roll film was introduced. Commercial processors developed the film, relieving the amateur's need for darkrooms. Now anyone could

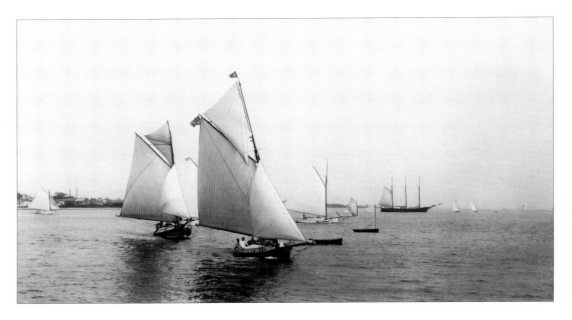

Amateurs photographed subjects which inspired them. This scene is from James Allen's series of yachting in New Bedford Harbor in 1886.

A portable roll film camera allowed Marian Smith, in 1901, to climb into a whaleboat suspended over the side of the California *to obtain this view of cutting-in.*

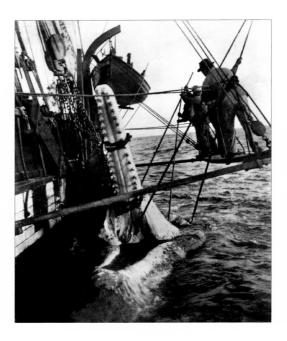

make photographs. Roll film increased the camera's mobility and allowed new subject matter. Many photographers recorded intimate views of family and friends. Others turned to the sea and to faraway places.

As amateur photography became popular, our collective vision expanded. Although often lacking technical quality, their snapshots had spontaneity and intimacy. Freed from tripods, photographers sought unusual angles and achieved interesting results with stop-action photography of sports such as diving or tennis. More and more the camera became an active player in everyday life.

Meanwhile, a few professionals continued to record New Bedford, notably Joseph G. Tirrell, Joseph S. Martin, Arthur F. Packard, and Edmund Ashley. Following traditions created in the wet plate era, this group used view cameras and large negatives to make detailed and carefully considered photographic views.

More portable equipment enabled these professionals to indulge in new areas of interest. Events became subjects. Arthur F. Packard photographed fires, working for the *New Bedford Standard* and for himself. *Standard* photographer Edmund Ashley photographed daily events. His photographs with dated and detailed newspaper stories create a unique record of the New Bedford area from 1900 to 1920.

Some New Bedford photographers looked inward, recording the city and its people. Others turned to faraway places, especially the distant ports visited by New Bedford whaleships. Before the technical advances of the dry plate and then roll film, it had been impossible to photograph whalers at sea. But from the 1880s until the

Joseph S. Martin recorded businesses and city streets. He documented nearly every building before the widening of downtown's major streets.

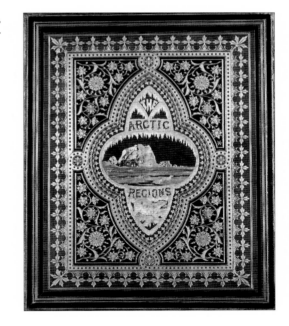

early 20th century when New Bedford's whaling industry finally collapsed, the camera was present aboard ship, recording whalers and the ports they visited.

Several photographers including Herbert Aldrich, Clifford W. Ashley, Albert Cook Church, and Robert Cushman Murphy documented the numerous steps required to convert earth's largest mammals into commodities of oil, whalebone and baleen.

The last two decades of whaling activity in the 19th century focused on large stocks of bowhead whales in Alaska's shallow seas. On the revenue cutter *Bear*, Herbert Aldrich, George Comer and an unidentified photographer, recorded both whaling operations and the Alaskan natives. Some photographs of Hawaii, a base for Arctic whalers, also came home to New Bedford.

Mention must also be made of Fairhaven artist William Bradford's voyage aboard the steamer *Panther* along Greenland's coast. Bradford, a seascape painter, commissioned the vessel and two Boston photographers, George Critcherson and John Dunmore, to record the eastern Arctic glaciers and the native people, in order to render them in his paintings. *The Arctic Regions*, a large folio album of mounted albumen prints from this voyage, was sponsored by Queen Victoria, and manufactured and sold by subscription. Bradford produced a lantern slide show that was shown at exhibitions including the 1876 *Philadelphia Centennial*.

A window back through time, photographs show us the people of the past, the world they inhabited, how they lived, worked, and played. This visual record by a diverse group of professional and amateur photographers allows us to scrutinize the way things looked, and to see from whence we came.

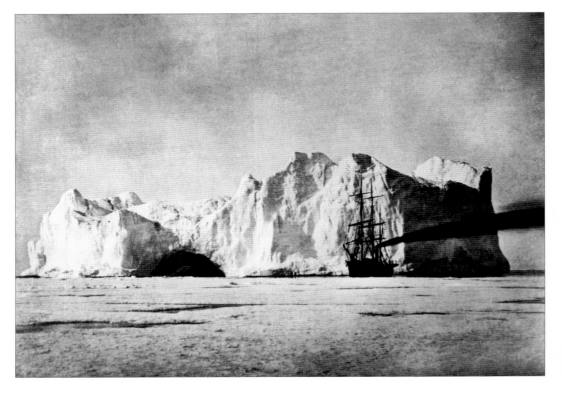

Photographs from William Bradford's travels among the icebergs of Greenland were hand tipped into his oversized volume, The Arctic Regions.

The Voyage

New Bedford's fame as a whaling capital is well deserved. By 1856, her fleet numbered 329 vessels, more than half of all America's whalers. The long and often dangerous voyages were recorded in logbooks, journals and letters home. Then in the 1880s, the advent of the dry plate, hand-held camera and eventually, roll film made photography at sea possible. The final decades of the American whaling industry were documented by Clifford W. Ashley, Albert Cook Church, Herbert Aldrich, George Comer, Robert C. Murphy, Marian Smith and a few anonymous photographers.

The perils of whaling in the far north are illustrated by the fate of *Helen Mar* as recounted by Koshan, a survivor of the 1892 ship wreck. This account appeared in the *Evening Standard* of November 7, 1892:

On October 6, when in lat. 71 degrees, 30 minutes north, the vessel took whales. The crew was so busy in trying out the catch that they did not observe the swift current carrying them toward a great ice floe. When they observed their peril there was no time to escape wreck. They got out two boats but had no time to get into them before the vessel came in contact with the floe. The sharp edge of the ice cut through her hull as a knife cuts cheese. In a moment two masts snapped off and fell on the ice and the vessel went down as though the bottom had dropped out.

Just as she was sinking, fifth mate William Ward and four men leaped on the ice floe and saved their lives. They saw the captain and the first mate struggling in the water but could not lend any help. In five minutes the captain and 33 men had found a watery grave. The men on the floe besides mate Ward were boatsteerer Anton Pargatino, cook Acy Kershaw and sailors Koshan and Perores. Their situation was very bad, as the floe was swept by icy winds and they had no shelter. They hoisted a shirt on a fragment of a spar and waited for help from some passing vessel. They spent 48 hours on the ice before their signal was seen by the steam whaler Orca.

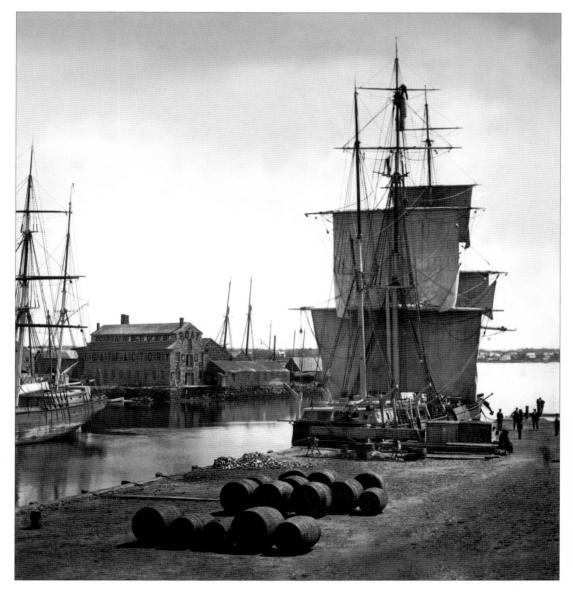

Bark *Helen Mar* at New Bedford
Stephen F. Adams

September 1871
Stereograph

Bark *Helen Mar* being outfitted with a new suit of sails. She set out for the North Pacific on September 26, 1871 and returned four and a half years later, laden with sperm whale oil and 36,085 pounds of baleen.

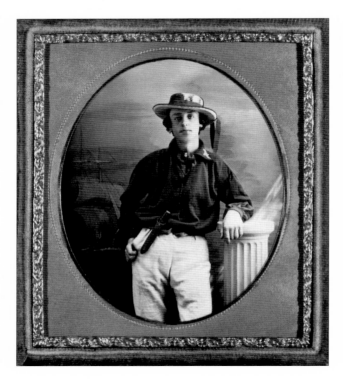

Jamie L. McKenzie April 1856
Unknown ⅙ plate daguerreotype

At fourteen, Jamie made his first whaling voyage on the bark *Reindeer*. Upon his return, he posed for this daguerreotype portrait, which he presented to his cousin, Mary E. Smith, at Edgartown in 1856. By age 23 he was first officer of the merchant vessel *Simoda*, but in January, 1862, he was washed overboard and lost.

Amos Haskins, Whaleship Captain Circa 1850
Unknown ⅙ plate daguerreotype

Amos Haskins, a Wampanoag Indian, sailed on six whaling voyages between 1839 and 1861 when he was lost at sea. He rose through the ranks until, in 1851, he was appointed master of the bark *Massasoit*, an unusual accomplishment for a Native American.

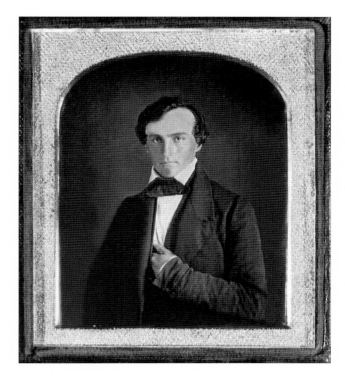

Richard Tobias Green Circa 1845
Unknown ⅙ plate daguerreotype

Richard Tobias Green sailed with Herman Melville aboard the
whaleship *Acushnet* from New Bedford in 1841. Eighteen months
later, the disgruntled pair jumped ship and lived for a time with
Marquesas Islanders. Melville turned this adventure into his book,
Typee, in which Green becomes the character Toby.

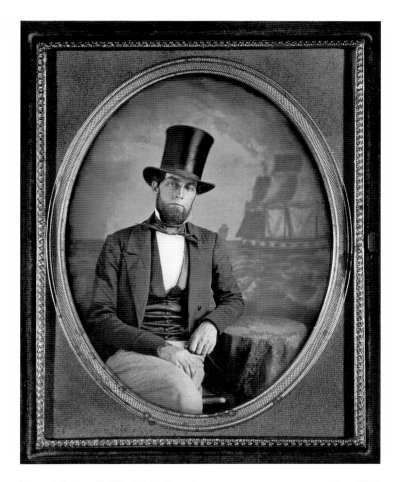

Edward S. Davoll, Whaleship Captain Circa 1850
Unknown ¼ plate daguerreotype

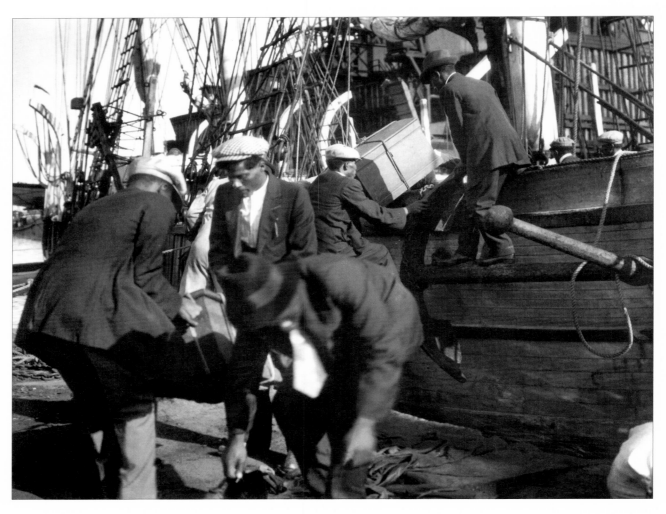

Greyhound Shipping a Crew
Clifford W. Ashley

1918
4" x 5" roll film negative

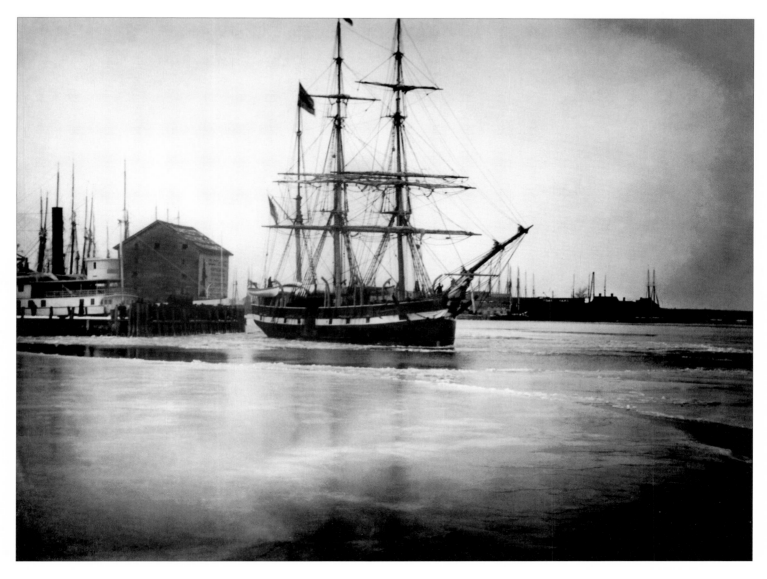

Bark *Tamerlane* January 23, 1885
Attributed to Joseph G. Tirrell 8" x 10" gelatin/silver print

The Arctic bound *Tamerlane* is led out of ice-choked New Bedford harbor by a tug. Although she was known to be a lucky ship because she brought in high profits, *Tamerlane* met her death during a midnight storm when she slammed into lava cliffs on Puna Coast, near Hilo, Hawaii. The veteran master and the first officer scandalized the crew and New Bedford by abandoning ship first. Captain W. F. Howland and 18 men were lost that night, February 2, 1892.

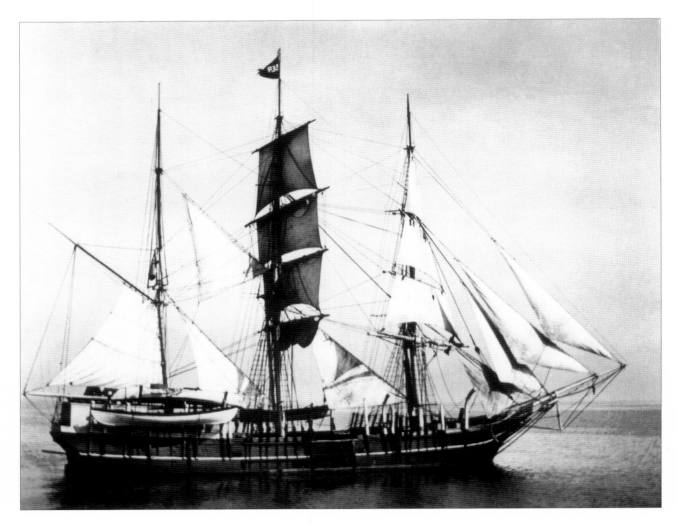

Bark *Bertha*, Outward Bound
Unknown

September 1907
4" x 5" gelatin/silver print

Bertha was launched on the 26th of December 1877, the last whaleship built in New Bedford. *Bertha* made twelve whaling voyages, was into the Cape Verde packet trade in 1917, and lost at sea on April 23, 1918.

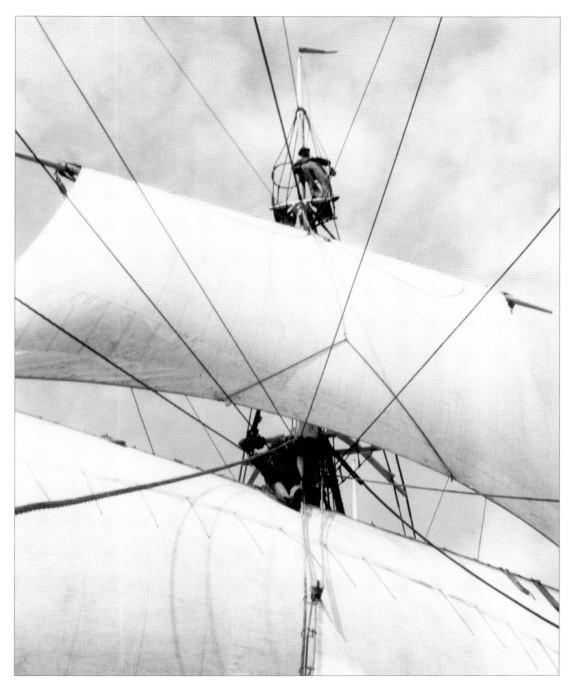

Masthead Man Aboard *Sunbeam* 1904
Clifford W. Ashley 4" x 5" roll film

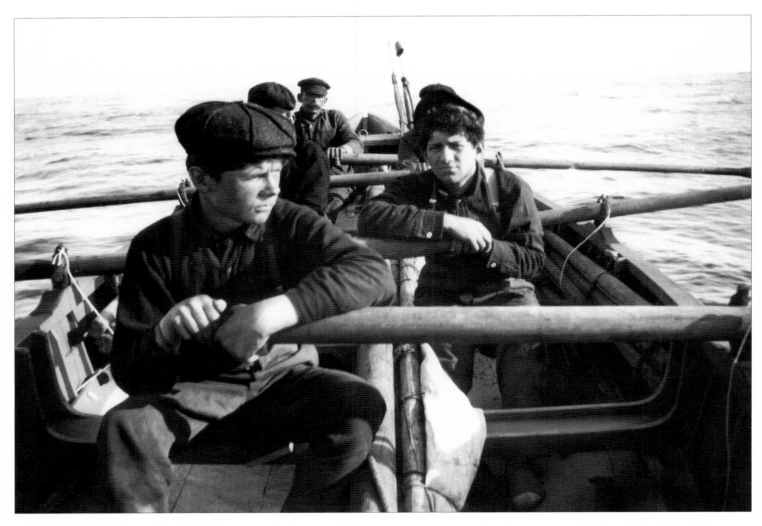

Whaleboat Crew from the *John R. Manta*
Captain Henry Mandley

1906
2⅜" x 3¼" roll film

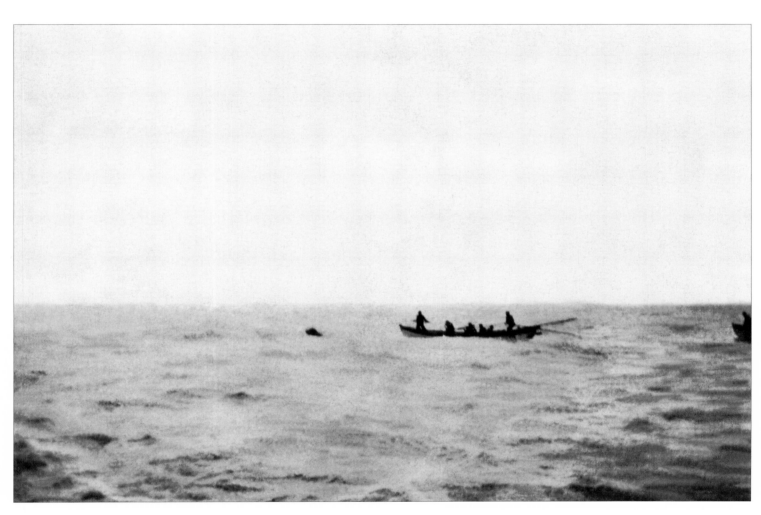

Officer About to Lance a Sperm Whale
Captain Henry Mandley

1906
2⅜" x 3¼" gelatin/silver print

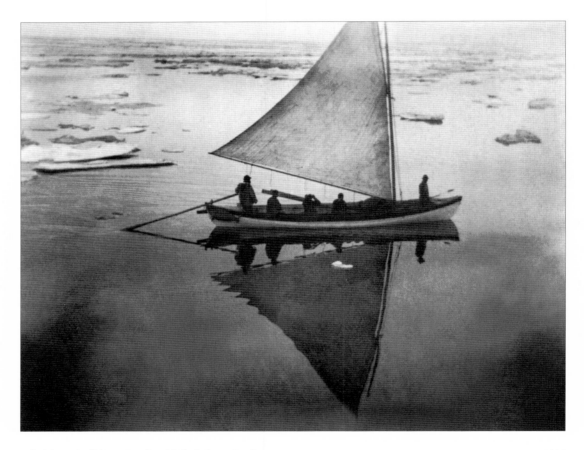

Whaleboat Stalking a Bowhead Whale in an Icy Sea 1887
Herbert Aldrich 4" x 5" albumen print

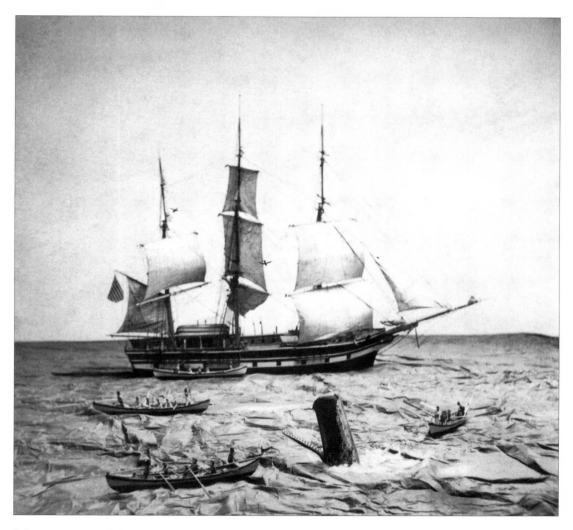

"Flurry or Dying #6" from the Stereoscopic Series, *A Whaling Voyage* 1868
Charles H. Shute & Son, Edgartown, Massachusetts Stereograph

Before cameras went to sea, the ingenious Charles H. Shute & Son staged twelve miniature tabletop scenes from a
whaling voyage. In this view, three boats await the whale's death.

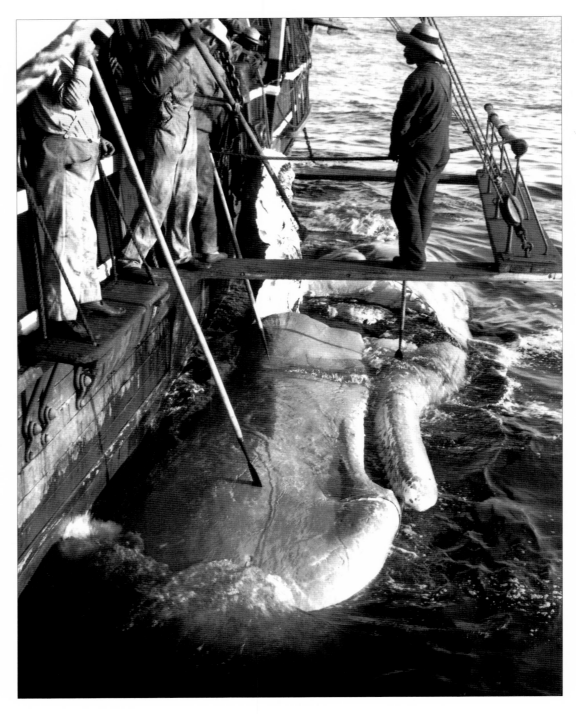

Cutting In Aboard *Sunbeam*
Clifford W. Ashley

1904
4" x 5" roll film

Jaw Nearly Clear 1901
Marian Smith 4" x 5" roll film

Marian Smith sailed with her husband Horace, master of the bark *California*. Presented with a camera and processing paraphernalia just before sailing, she recorded the voyage and sent photographs home to her friend Elizabeth Ray in New Bedford. Many of her views were later distributed as postcards by the Hutchinson Company. Marian Smith described her darkroom in a letter:

> *…Where do you suppose my developing room is? First, I tried the Bosun's locker, a little windowless room on deck but I could use it only at night because it had some light cracks in it. Then I thought of the run, the extreme rear end of the lower hold. So the steward arranged the boxes and cases in such a fashion that I could climb up and down easily and have endless tables on which to work. There is always plenty of air down there.*

In this view, men on the cutting stage use long-handled spades to separate a sperm whale's tooth-studded jaw from the body so it could be brought aboard.

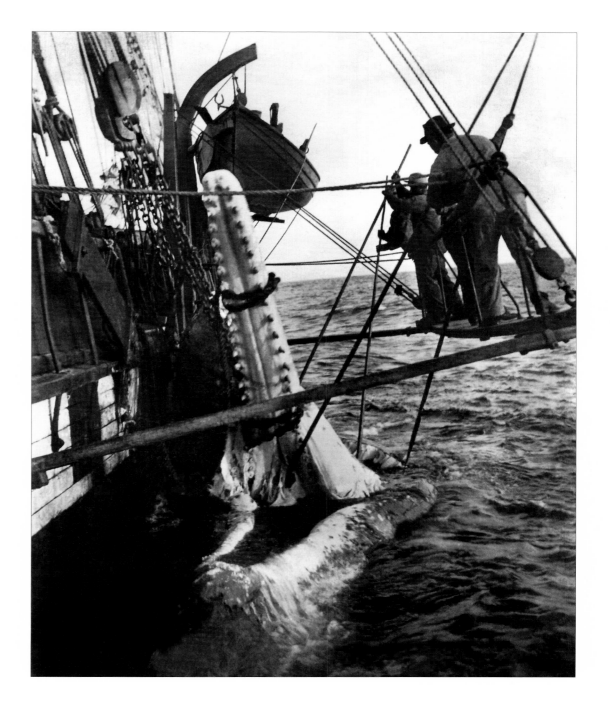

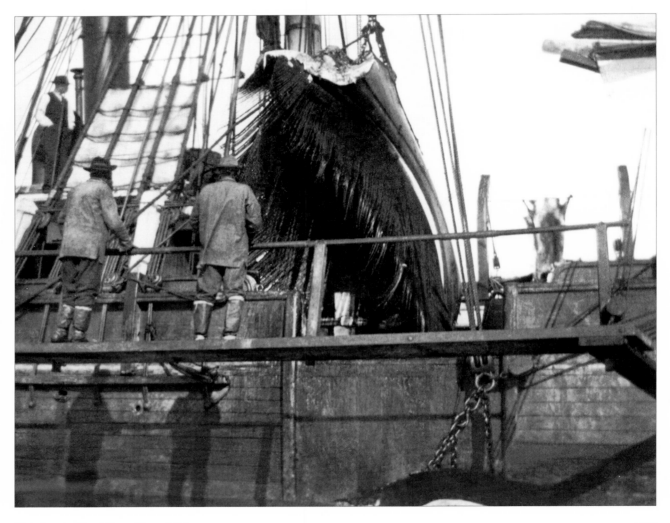

Hoisting the Head Bone Aboard *Beluga*
Herbert Aldrich

1887
4" x 5" albumen print

By the 1880s, whale oil had been superseded by petroleum products in most applications. But some whales offered another valuable commodity—baleen—which was found in the filter-feeding Arctic bowhead whale. Thus the focus of the industry shifted to the treacherous seas around Alaska.

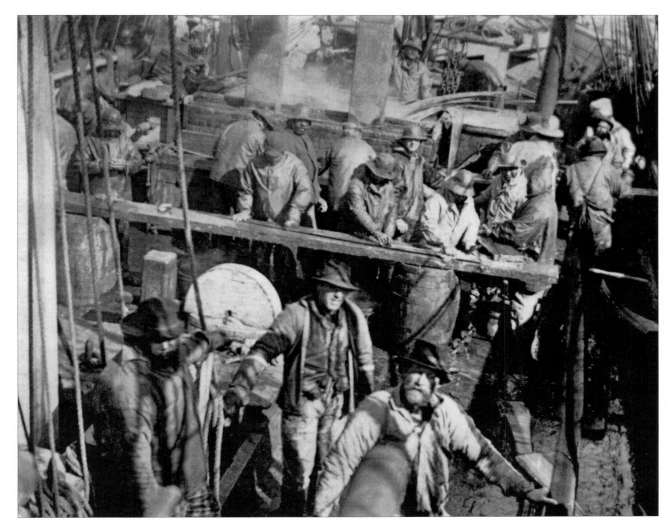

Washing Baleen aboard a Whaleship 1887
Herbert Aldrich 4" x 5" albumen print

Herbert Aldrich, a writer with the *Evening Standard*, journeyed for eight months to the Arctic, working on several different vessels. He photographed the ships, the ice, whalers and their work. Humbled by his experiences, he wrote: "I had seen nothing of the hardships of Arctic whaling, yet enough to convince me that no men deserve what money they earn more than do these."

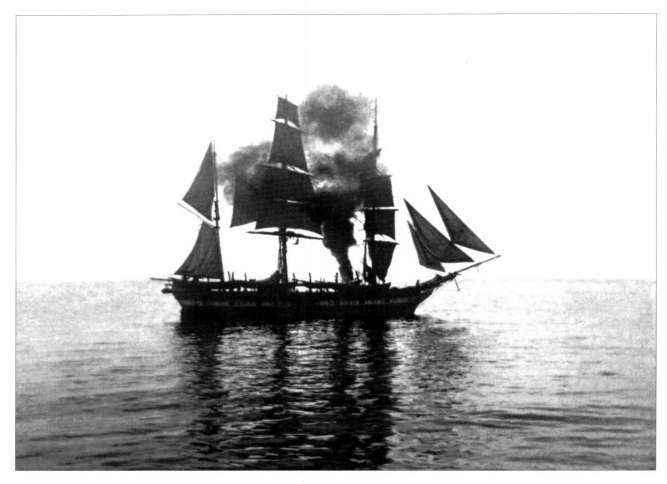

Bark *Helen Mar* 1887
Herbert Aldrich 4" x 5" albumen print

Aldrich developed and printed his photographs aboard ship. He used the recently introduced film negatives rather than the brittle glass negatives used at the time. A published account of his experiences appeared in 1888 in the book, *Arctic Alaska and Siberia, or, Eight Months with the Arctic Whalemen.*

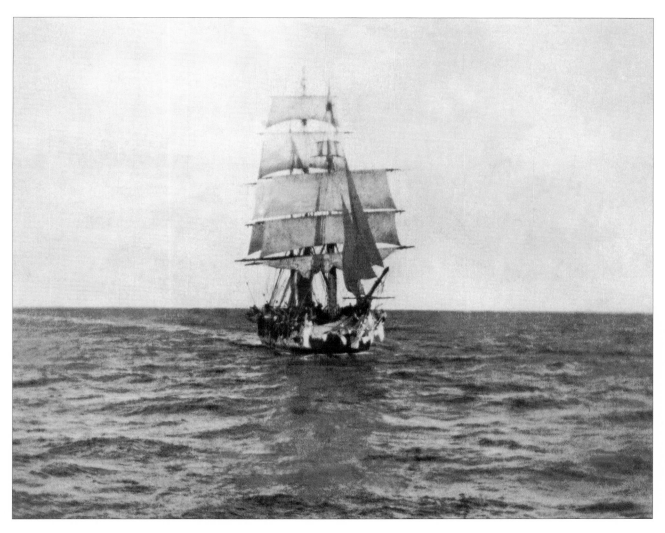

Thrasher, Her Bows Iced Up after an Autumn Gale 1887
Herbert Aldrich 4" x 5" albumen print

As the fleet headed home, Aldrich reflected on his good fortune in encountering an unusually mild Arctic winter: "…When I went on deck, I found myself in the Arctic Ocean. I had looked into the ocean before, but this was my first being within its waters. I knew that old whalemen—men who had braved every sort of danger—the storm, reef, hurricane—dreaded no place more than this. I knew that its gales were terrific, its fogs dangerous, and its ice treacherous. I knew also that victims were called for unceremoniously, and that shipwreck, with possible loss of life, was a foregone conclusion every year."

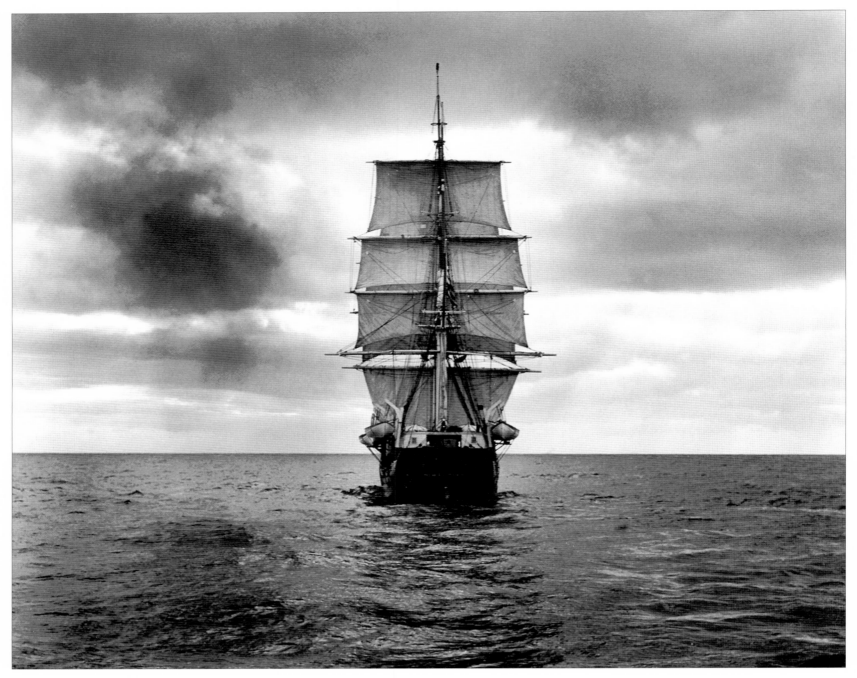

Wanderer
Albert Cook Church

Circa 1920
3¼" x 4¼" dry plate

Wanderer was the last square-rigged whaleship to leave New Bedford. Built in Mattapoisett in 1878, she made 23 voyages from New Bedford and San Francisco before being wrecked off Cuttyhunk Island in 1924.

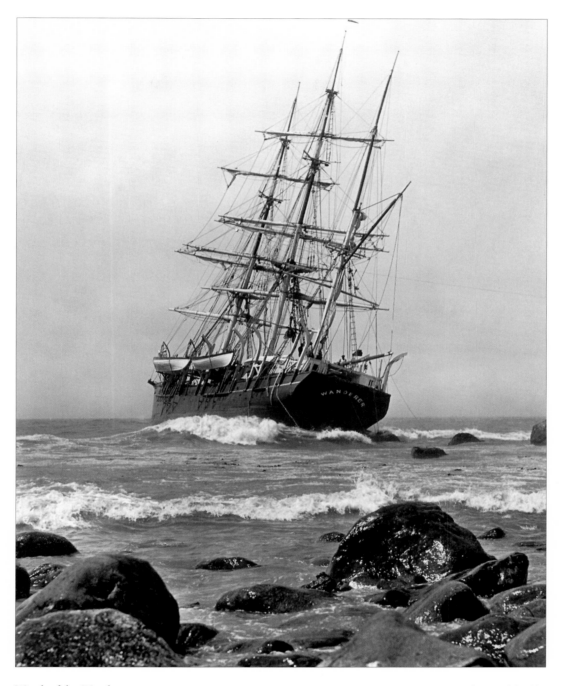

Wreck of the *Wanderer* August 26, 1924
Albert Cook Church 3¼" x 4¼" dry plate

Captain Antone T. Edwards had anchored *Wanderer* off Cuttyhunk and gone ashore to hire more crew. That night, gale winds and 35–foot waves drove her onto the rocks where, over time, the surf pounded her apart.

Far Away Places

New Bedford's fleet prowled the globe in search of whales, often making port in exotic, out of the way harbors not frequented by merchant vessels. Whalers were trail blazers, sailing in uncharted waters and putting in at far away lands, but few of these adventures were photographed. By the time the camera was ready for sea, only one epoch, the whaler's penetration of the Arctic, was left to record. Photographs also survive from ports such as Horta, Fayal and Honolulu. Visual confirmation of a wild frontier comes from the work of Herbert Aldrich, George Comer, Ben Killian, and an unidentified photographer accompanying the 1886 cruise of the revenue cutter *Bear*.

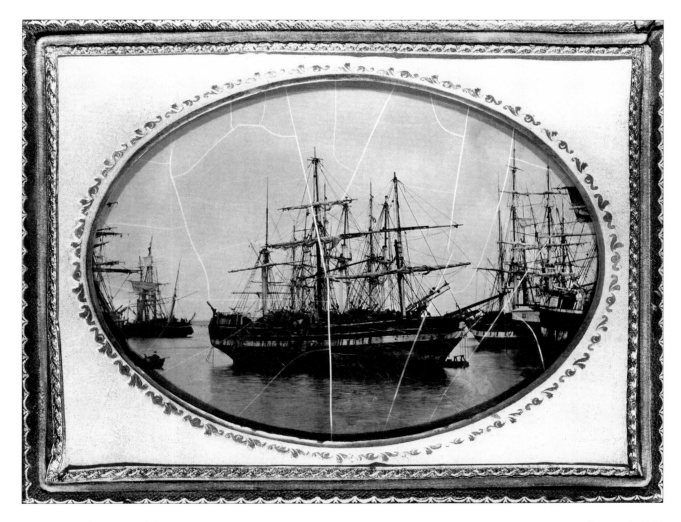

Benjamin Tucker at Honolulu
Hugo Stangendawld

January 1, 1857
½ plate ambrotype

On her return passage from the Arctic, *Benjamin Tucker* encountered a storm which damaged her rigging. Captain Spencer commissioned this ambrotype depicting the damage to send to the vessel's owners. It is the earliest known photograph of an American whaleship.

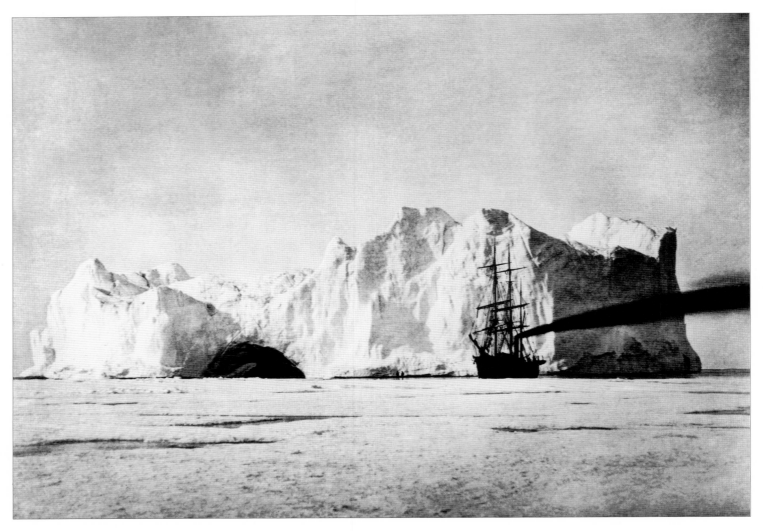

Panther and an Iceberg
John Dunmore and George Critcherson

1869
Albumen print

Marine painter William Bradford hired the steam bark *Panther* to take him and his party to the ice fields of Greenland. Among his group were photographers John Dunmore and George Critcherson. The resulting photographs became the cornerstone of Bradford's book, *The Arctic Regions*, and served as studies for Bradford's Arctic paintings.

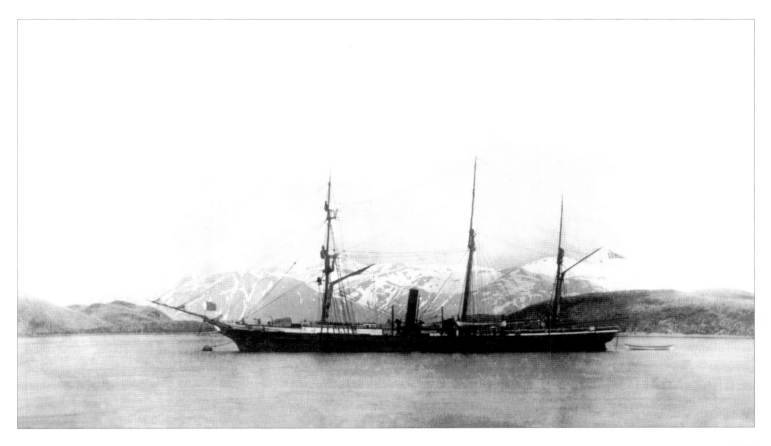

Revenue Cutter *Bear* 1886
Unknown 4½" x 7½" albumen print

Whalers were the first modern men to have extended contact with the Eskimos. When whaleships began to winter over in the Arctic, a partnership between whalers and Eskimos was established. The Eskimos shared their knowledge of survival in the hostile Arctic. They also worked as whalers and brought furs and meat to the ship to trade. For their part, the whalers brought trade goods, guns, ammunition, clothing and food.

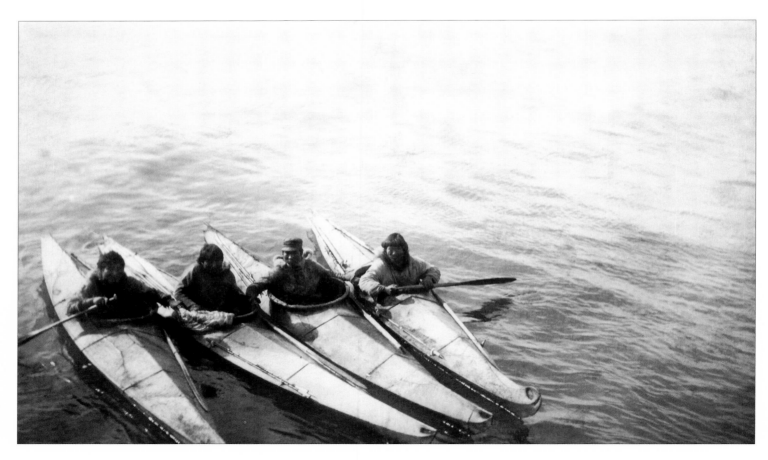

Native Alaskans in Skin Kayaks, Revenue Cutter *Bear* Series 1887
Unknown 4½" x 7½" albumen print

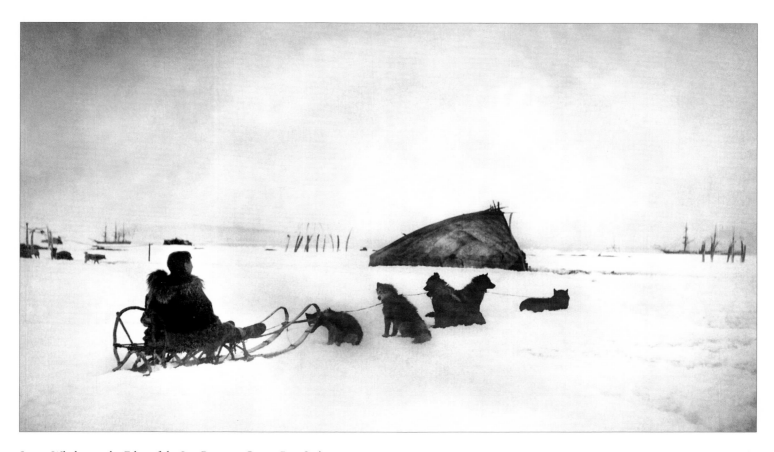

Steam Whalers at the Edge of the Ice, Revenue Cutter *Bear* Series 1887
Unknown 4½" x 7½" albumen print

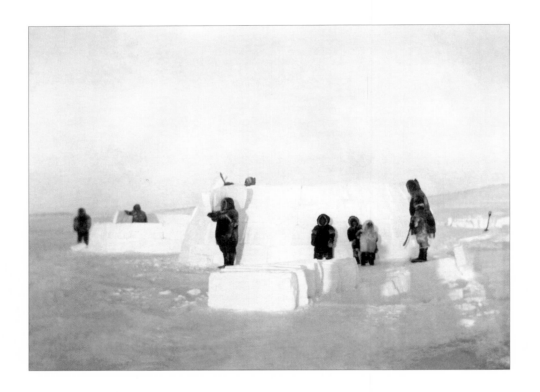

Snow House Construction
George Comer Series #88

February 7, 1902
4" x 5" gelatin/silver print

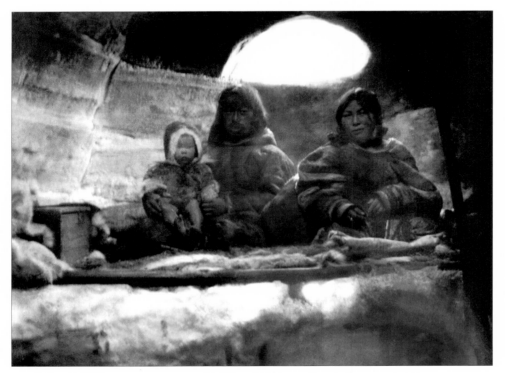

Snow House Interior
George Comer Series #22

December 1, 1900
4" x 5" gelatin/silver print

George Comer, captain of the whaling schooner *Era,* made five voyages to Hudson Bay between 1895-1906. But his interests were not restricted to whaling. Comer conducted ethnographic studies of the Eskimos of Hudson Bay. He took photographs, collected information and artifacts, made sound recordings, and plaster casts of Eskimo faces. A series of his card-mounted 4" x 5" Hudson Bay Eskimo prints was offered for sale and saw limited distribution.

Eskimo Ritual
George Comer

Circa 1902
4" x 5" gelatin/silver print

In this ritual, a Shaman works to free himself
from bondage.

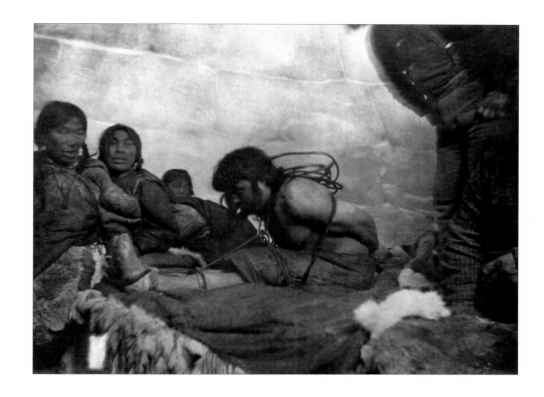

Muegulustso Game
George Comer Series #40

January 23, 1901
4" x 5" gelatin/silver print

A party of Kimipitive Eskimos play at a game
called Muegulustso, where a rapidly spinning
eyelet is suspended from the ceiling on a string.
The players compete to be first to insert their
spear point through the eyelet.

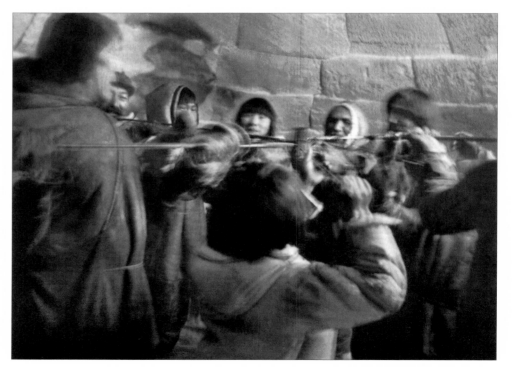

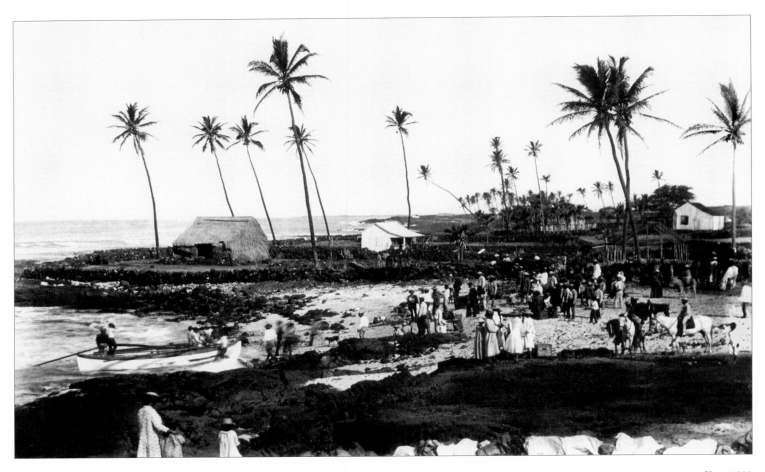

Hawaii
Unknown

Circa 1880
6¼" x 9¼" albumen print

Vessels whaling in the Arctic often made port in Hawaii to replenish supplies and overhaul their ships.

Hawaii Circa 1880
Unknown 6¼" x 9¼" albumen print

No setting could offer greater contrast to the frozen Arctic and sailor's fare of "salt horse" than the palm trees and extravagant luaus of Hawaii, as pictured here.

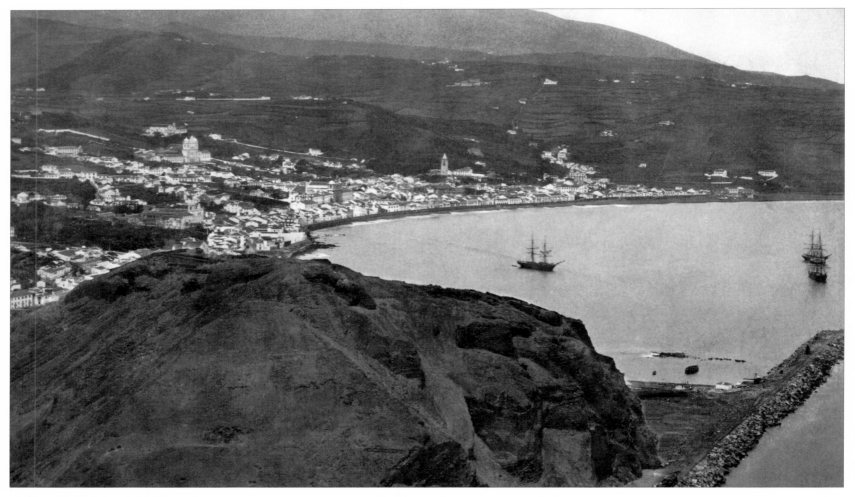

Horta, Fayal, Azores Islands
Unknown

Circa 1880
3½" x 8½" albumen print

Whaleships would routinely anchor in Horta's bay for fresh fruit and other provisions. Once here, men were often recruited to serve as whalers, thus receiving passport to America. Azoreans, Cape Verdeans and West Indians made up the majority of East Coast whalers even before the turn of the century.

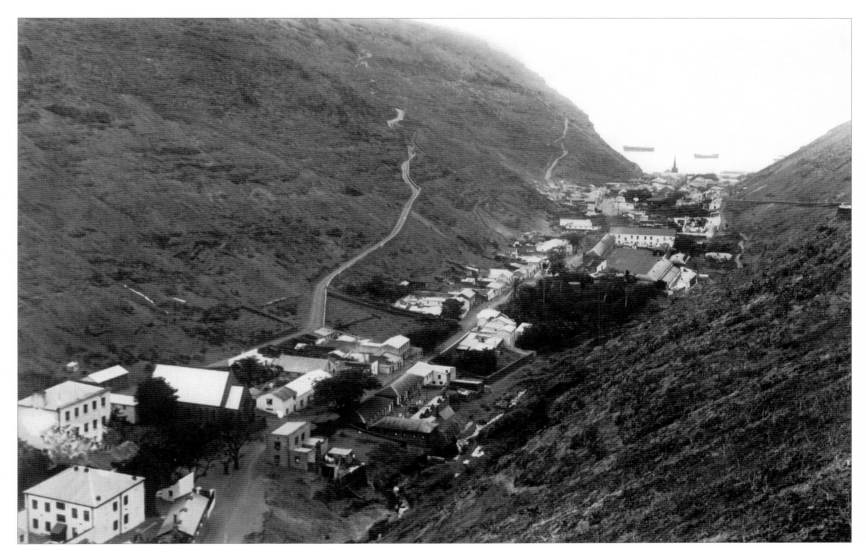

Jamestown, Saint Helena
B. Grant

Circa 1880
6¼" x 8¼" albumen print

"The entire town of Jamestown" reads the caption on the reverse of this photograph.

The Waterfront

❧

The waterfront has always been a focal point for New Bedford. In the nineteenth century it harbored the whaleships which brought prosperity to the city. Coasting schooners, Cape Verde packets, fishing boats, pilot boats, light ships, island steamers, barges, steam tugs and hundreds of smaller craft had their places with the whalers at the wharves. The earliest photographs, dating from 1860 to 1880, show whaleships in top working condition. But the decline of the industry becomes evident in the neglected hulks huddled around the wharves by the century's end.

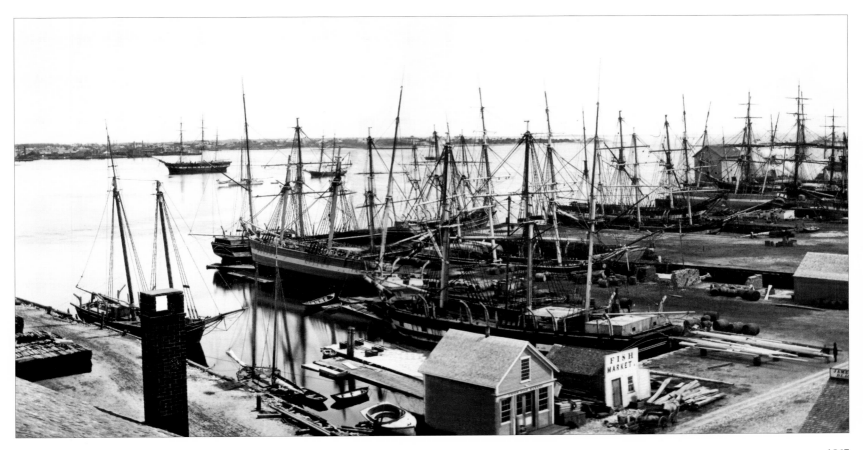

Bird's-Eye View of New Bedford Waterfront
Stephen F. Adams

<div align="right">
1867
Two stereographs
</div>

On the wharf are spars, casks of provisions going aboard and oil coming ashore, piles of wood, and bricks for rebuilding tryworks. In the water, work-floats surround freshly painted vessels, well-rigged and soon to be bound for sea. The ship cruising in the middle of the harbor is the *U.S.S. Constitution.*

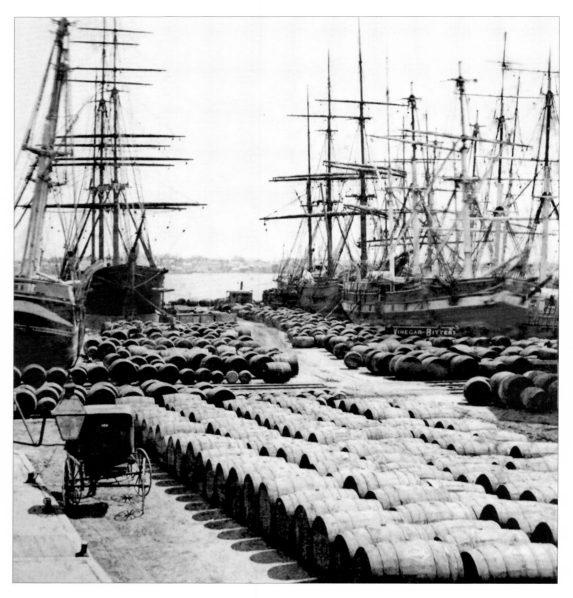

Whaleships and Casks of Whale Oil at Central Wharf Circa 1870
Stephen F. Adams Stereograph

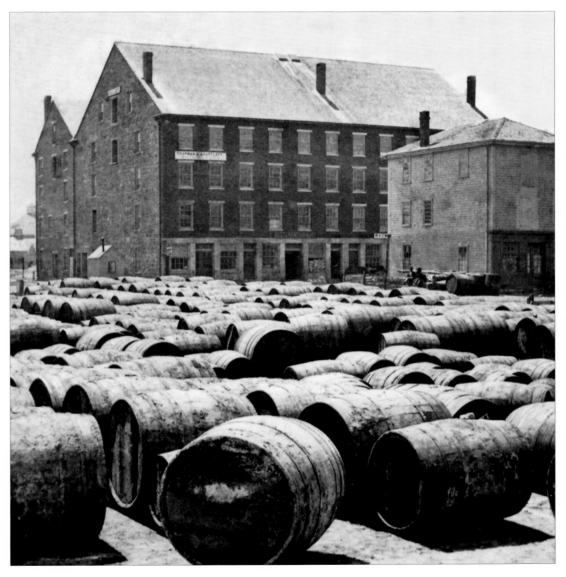

Casks of Whale Oil at Central Wharf
Stephen F. Adams

Circa 1870
Stereograph

At the head of Central Wharf is the Taber Block (center), which at the time housed sailmakers, chandleries, agents and other maritime trades and services.

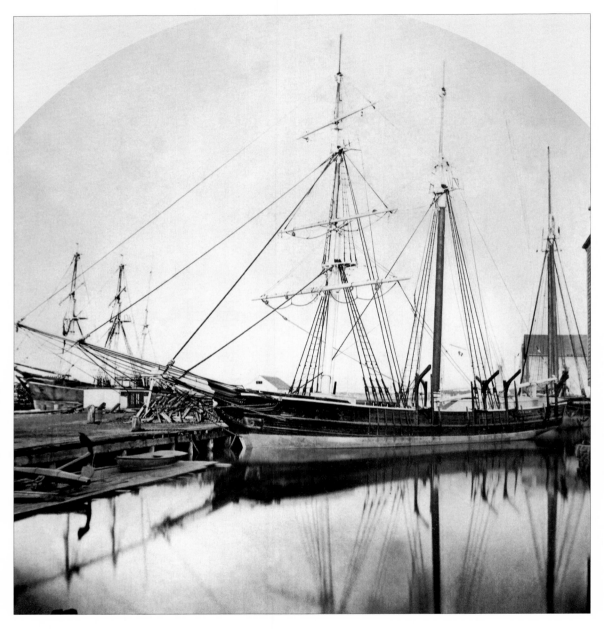

Brig *Eunice H. Adams*, Built 1845
Unknown

Circa 1870
10" x 11" albumen print

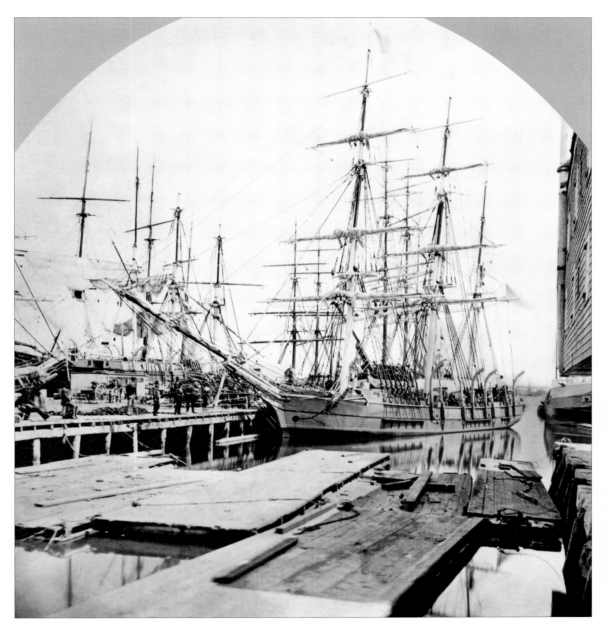

Bark *Tropic Bird*, Built 1851 1876
Unknown 9¾" x 11" albumen print

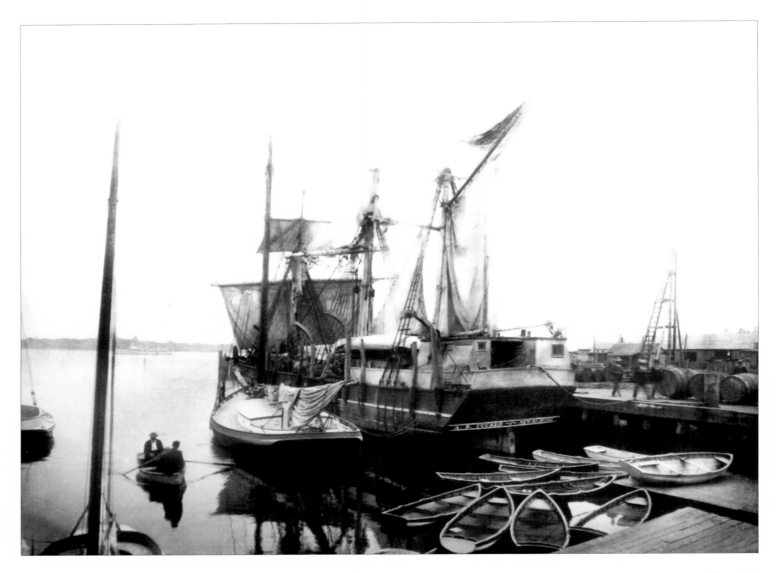

Bark *A. R. Tucker* Damaged by a Storm at Sea
Joseph G. Tirrell

Circa 1900
8" x 10" gelatin/silver print

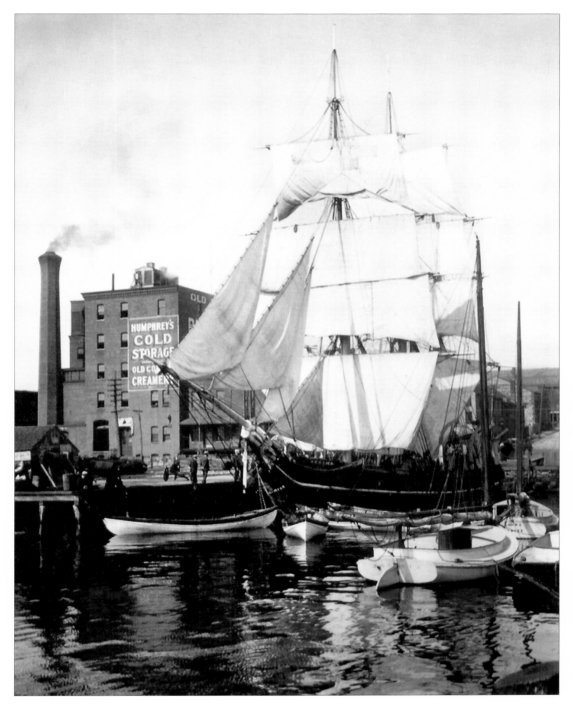

Bark *Bertha* Dries Her Sails July 1907
Unknown 4" x 5" gelatin/silver print

Al Soul Tripp, Boat-letter
Unknown

Circa 1906
3¼' x 4¼' gelatin/silver print

Al Soul Tripp recalled the heyday of the boat-letting business in the New Bedford *Evening Standard*, October 6, 1906: "The business of boat-letting today does not compare very well with the state of the industry before the advent of electric cars. Before such conveniences as these, and before steamboat excursions and municipal parks were thought of, about all the respectable citizens had for enjoyment was to go out sailing or rowing."

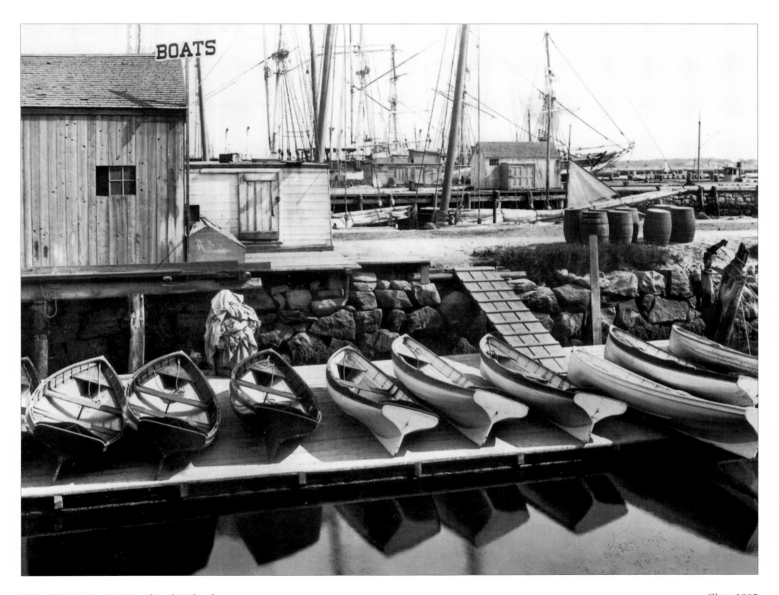

Tripp's Boats To Let, Merchant's Wharf
Unknown

Circa 1885
6½" x 8½" gelatin/silver print

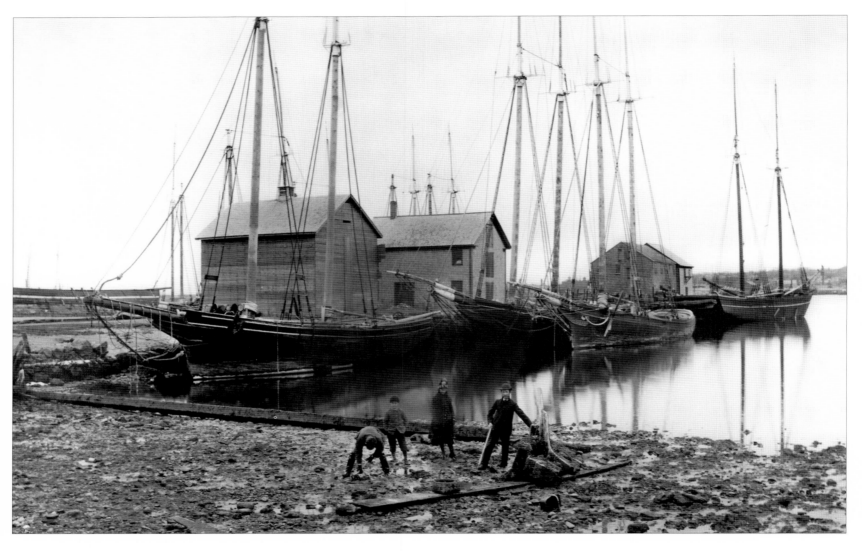

Schooners at Old South Wharf, Fairhaven, Circa 1890
Henry P. Willis 5" x 8" dry plate

Old South Wharf is one of the nation's oldest docks, constructed around 1710. In the early days of whaling, the wharf was home to cooper shops, a newspaper, bakery and shipyard.

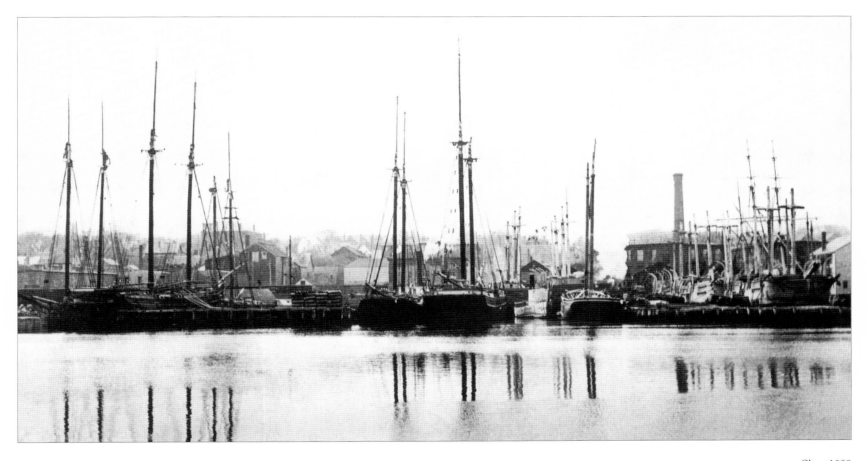

Schooners North of the New Bedford Bridge
Clifford Baylies

Circa 1890
5" x 8" cyanotype

By the end of the century schooners brought stone, lime and lumber to build a booming city, whose prosperity now came from the textile mills rather than from whaling.

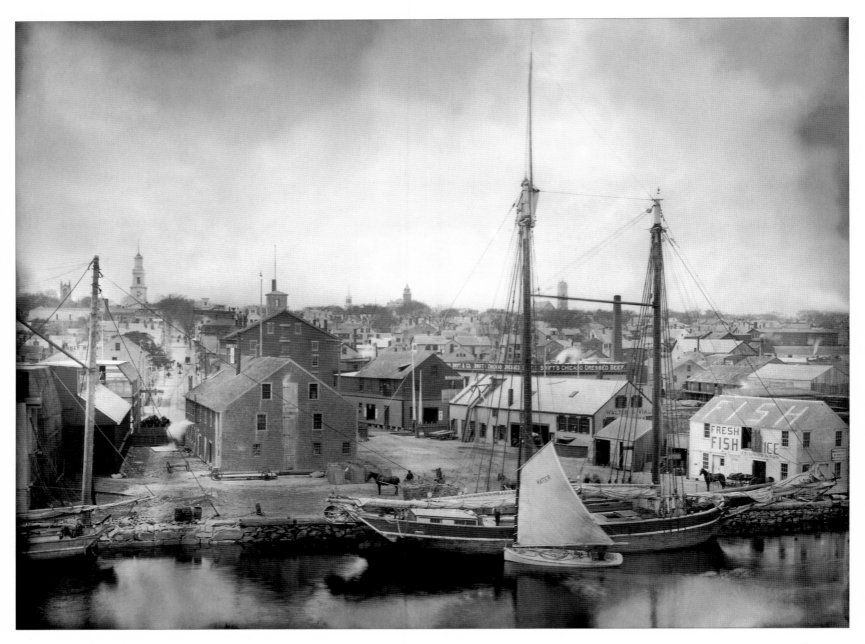

Schooner Unloading Bricks
Henry P. Willis

Circa 1890
6½" x 8½" dry plate

A schooner off-loads a shipment of bricks into special low-hung wagons for transport to the construction site, while a water boat, *The Friends*, supplies her with fresh water.

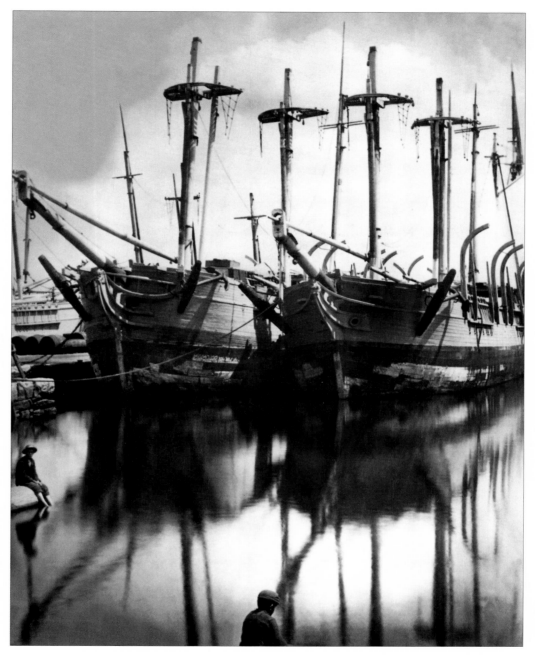

Rousseau and *Desdemona* Circa 1890
Unknown 8" x 10" gelatin printing-out-paper

Between 1885 and 1893 *Rousseau* and *Desdemona* sat rotting side by side. Scars from decades at sea covered their hulls, while scraps of rigging hung like cobwebs from what little remained of their spars. Many photographers found these derelict whalers an irresistible subject, full of romantic and symbolic possibilities.

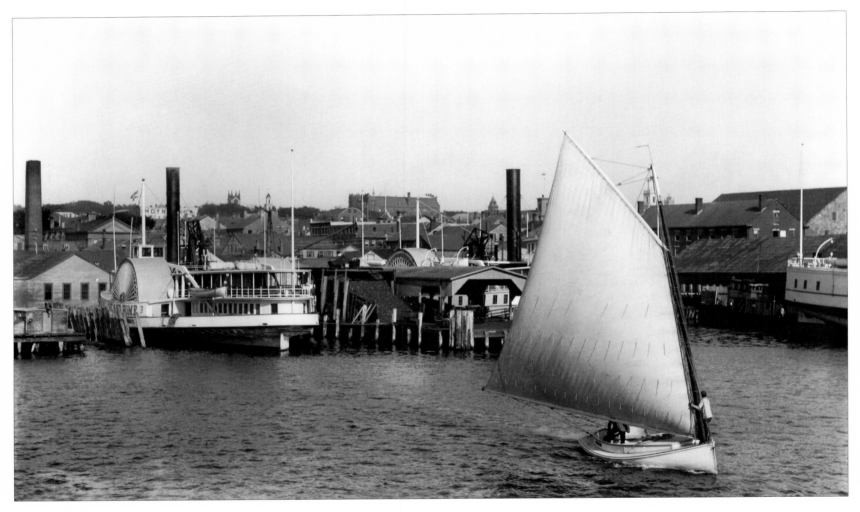

Steam Ship Piers
Clifford Baylies

<div align="right">Circa 1890
5" x 8" dry plate</div>

The New Bedford and New York Steamship Company occupied a long, narrow, roofed-over wharf which could accommodate the larger vessels used on the runs between New Bedford and New York. The ships of the New Bedford, Martha's Vineyard and Nantucket Steamship Company occupied a smaller wharf nearby. From left to right are the *Island Home,* the *Nantucket* (behind the cat boat), and the stern of the *City of Brockton* (far right).

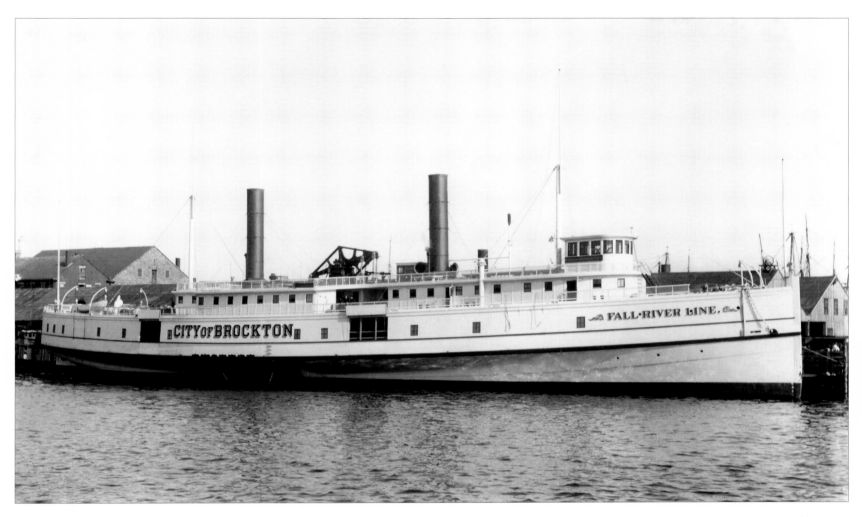

Steam Ship Piers
Clifford Baylies

Circa 1890
5" x 8" dry plate

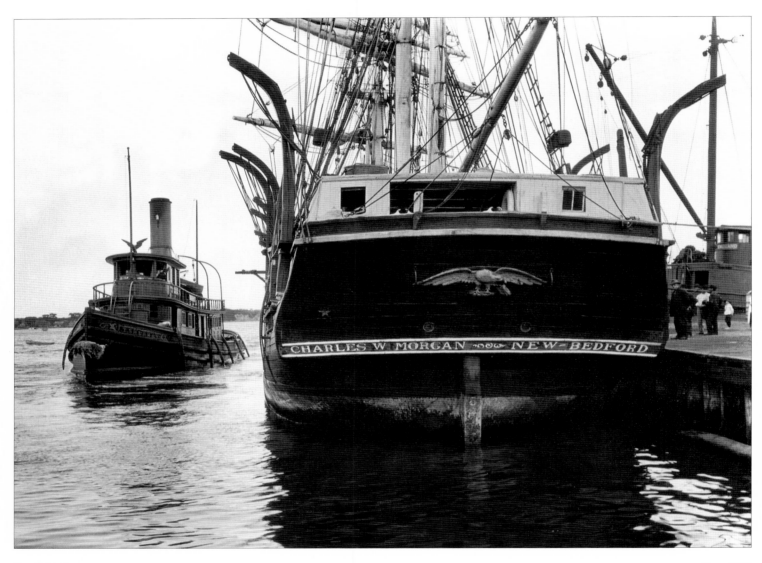

Tug *J. T. Sherman*
Albert Cook Church

Circa 1900
4" x 5" gelatin/silver print

In 1894, Jesse T. Sherman consolidated the interests of all the major towboat owners into the New Bedford Towboat Company. To his fleet of *Nellie* and *Charlie*, he added *S. C. Hart* in 1896 and the *J. T. Sherman*, his largest tug, in 1898.

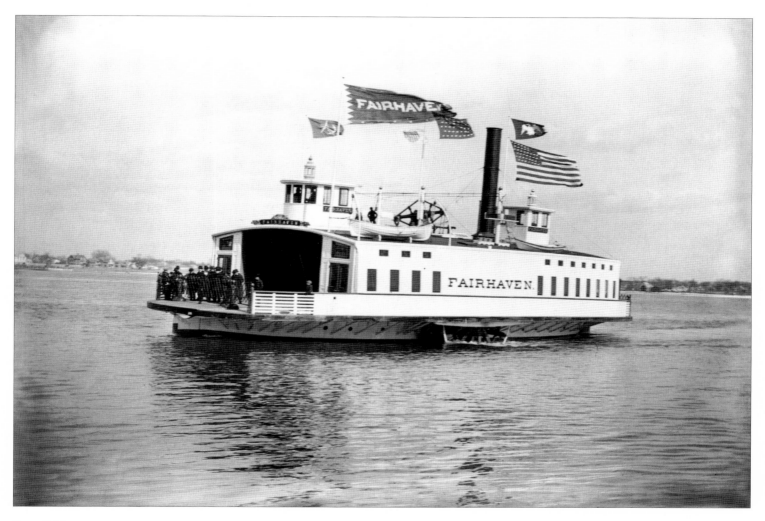

Ferry *Fairhaven* February 24, 1896
Unknown 5" x 7" dry plate

On this day, a salute fired by the militia, a set of colors presented to Captain Harvey H. Webber, band music and about 300 passengers helped send the *Fairhaven* on her maiden trip across the New Bedford Harbor. By the end of the day about 3,000 tickets had been sold. For more than 100 years, Fairhaven and New Bedford were linked by ferry. The *Fairhaven* was the last of these ferries, steaming nineteen round trips a day across the harbor.

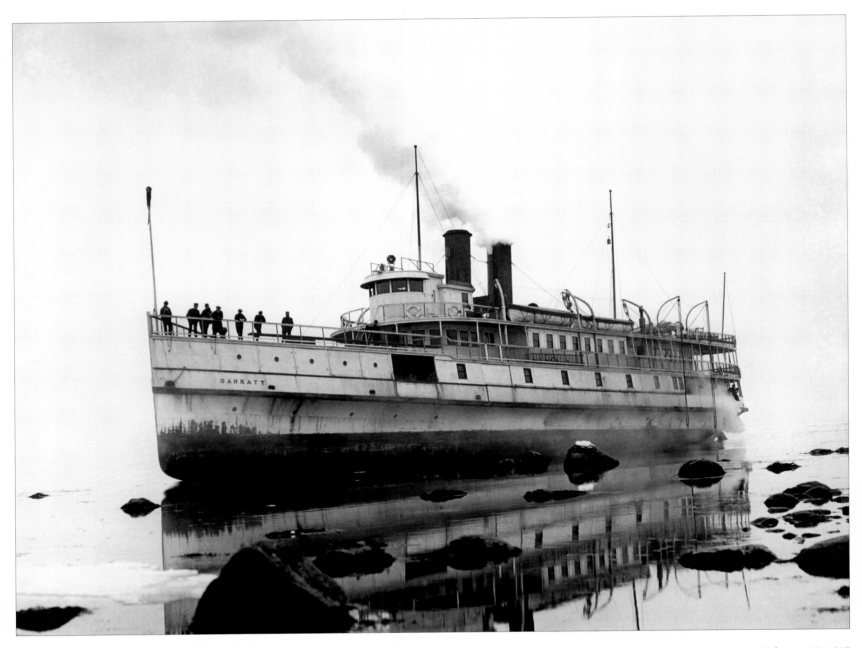

Sankaty Goes Ashore
Edmund Ashley

February 20, 1917
5" x 7" dry plate

While bound from Edgartown to New Bedford in a heavy fog, *Sankaty* ran aground, badly damaging her bottom.

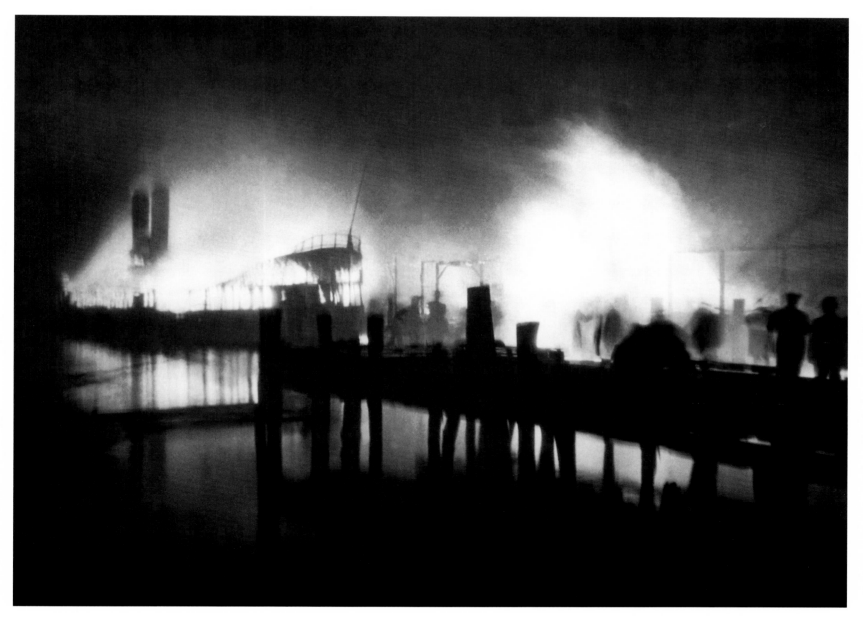

Sankaty On Fire
William Wood

June 3, 1924
8" x 10" gelatin/silver print

Sankaty's demise occurred in New Bedford Harbor on the night of June 3, 1924, when she caught fire, burned through her deck lines and drifted across the harbor. A floating inferno, *Sankaty* drifted into the *Charles W. Morgan* which took fire and only narrowly escaped.

Waterfront Trades

On the shores of the Acushnet River both in New Bedford and Fairhaven, shipbuilders, riggers, sailmakers, sparmakers, carpenters, painters, boatbuilders, caulkers, coopers, and blockmakers serviced the fleet. Whether the task involved turning a windlass barrel on a simple lathe or heaving down a 300-ton whaleship, all work was done by hand. Some activities such as coopering and heaving down are well documented. Yet shipbuilding, which continued in New Bedford until 1877, went unrecorded by area photographers.

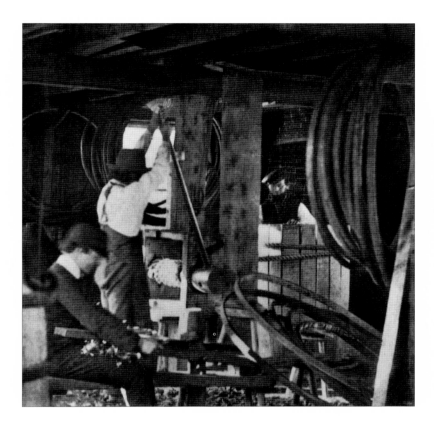

Cooper Shop Interiors Circa 1860
Bierstadt Brothers Stereograph

These views of the interior of a cooper's shop are among the earliest New Bedford area photographs of men at work. That they are interiors makes them all the more extraordinary. The men are carefully posed to illustrate as much of the coopering procedure as possible.

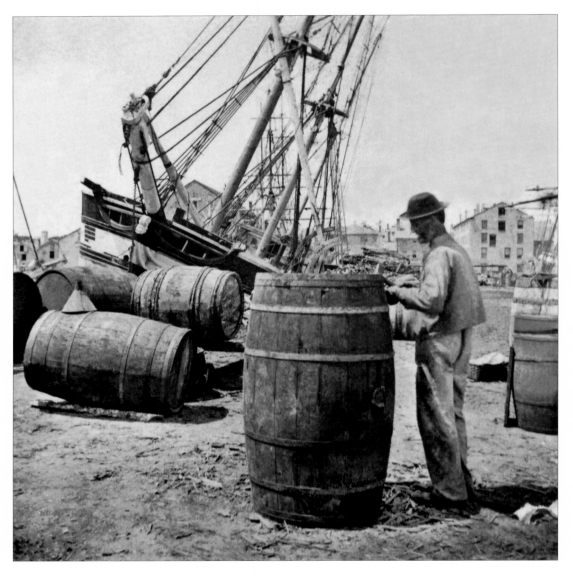

Cooper Heading a Cask Circa 1870
Thomas E. M. White Stereograph

Stereographs provide the first photographic documentation of waterfront tradesmen. This view is carefully composed to illustrate the cooper, the casks and the whaleship, and to give a strong sensation of depth.

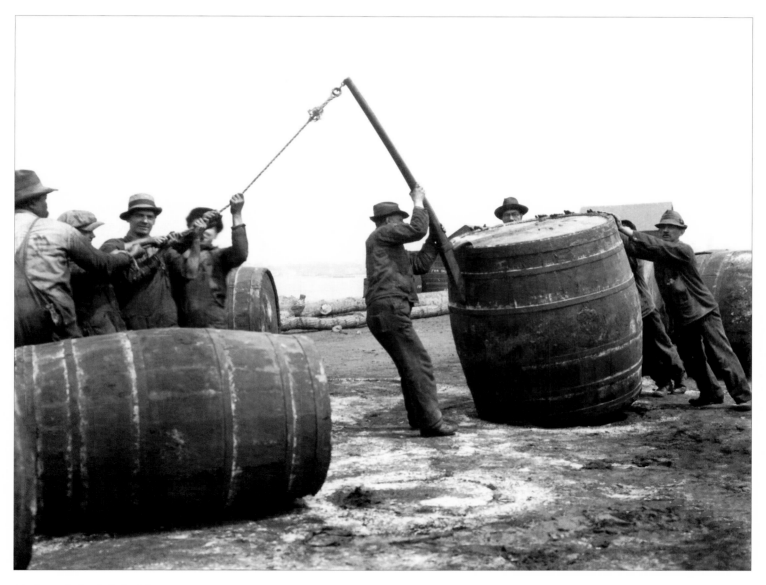

Moving a Cask of Whale Oil
Clifford W. Ashley

Circa 1910
4" x 5" nitrate negative

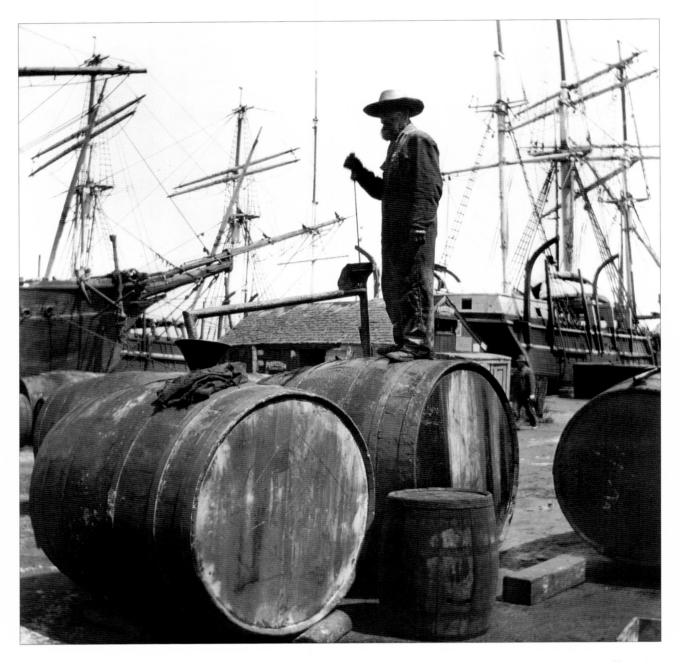

Pumping Whale Oil From One Cask To Another
Albert Cook Church

Circa 1910
3½" x 3½" nitrate negative

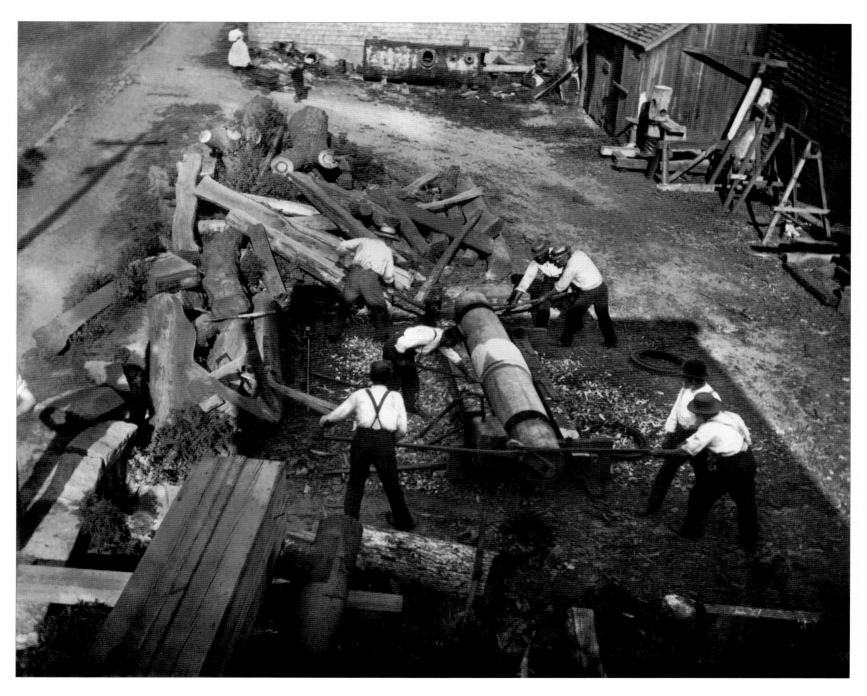

Turning a Windlass Barrel on a Hand-powered Lathe
Unknown

Circa 1880
4" x 5" dry plate negative

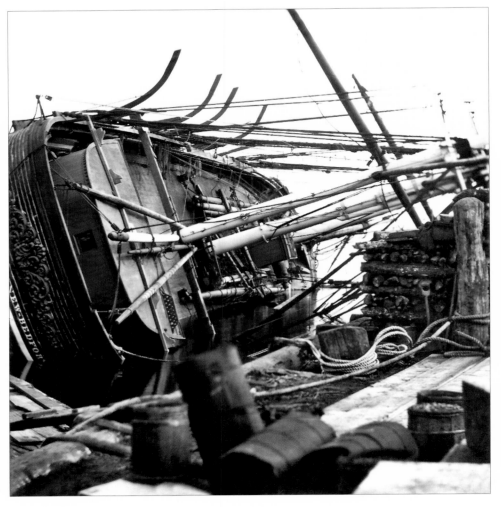

Sophia Thornton Hove Down
Bierstadt Brothers

Circa 1860
Stereograph

One of the most dramatic occurrences on the waterfront was the heaving-down of a whaler. An alternative to hauling, it allowed for the replacement of a vessel's sheathing and any other repair needed below the waterline.

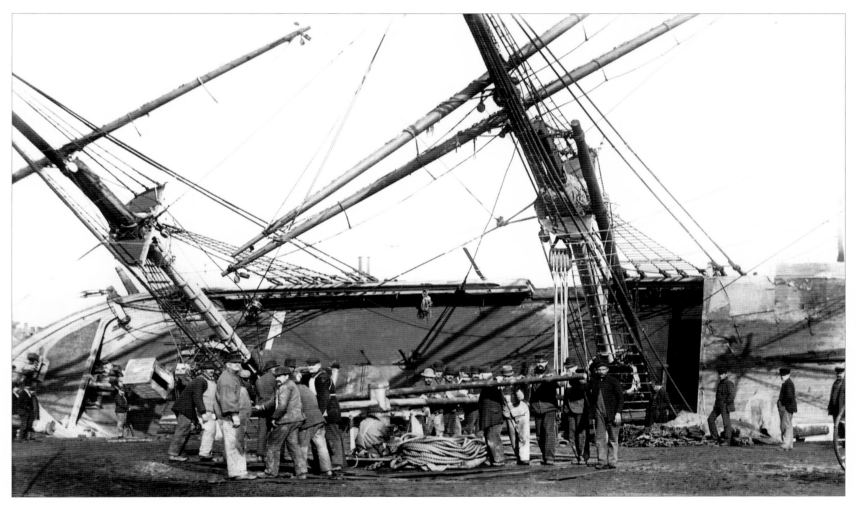

Heaving Down the Bark *Josephine*
Clifford Baylies

Circa 1890
5" x 8" dry plate negative

Vessels were hove down until they lay entirely out of the water on their beam end. Workers could repair the hull from a large platform moored to the vessel. Sometimes holes were drilled into the hull to check for rot. Caulkers made sure seams were tight by forcing oakum into them with their mallet and iron. If the whaler was headed for the Arctic the bow would be reinforced with heavy oak planks and an iron shoe to withstand the impact of the ice.

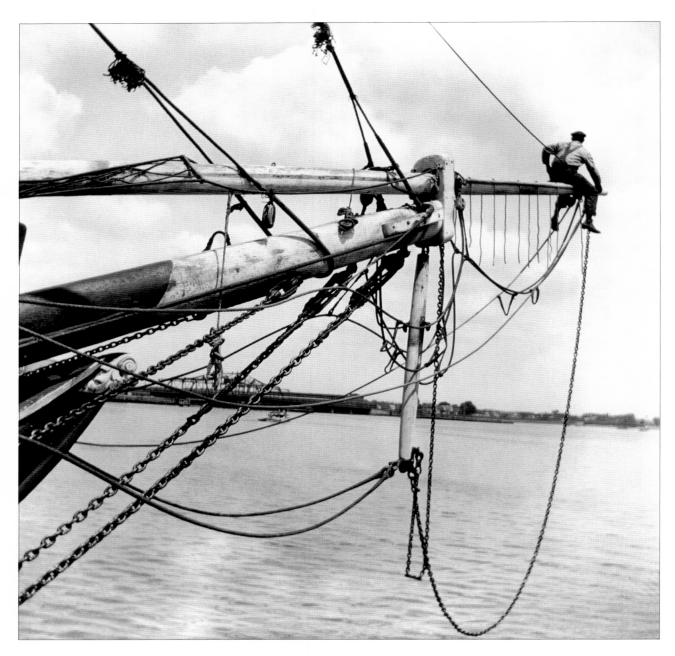

Rigging the Jib Boom, *Charles W. Morgan*
Albert Cook Church

Circa 1920
2½" x 3½" nitrate negative

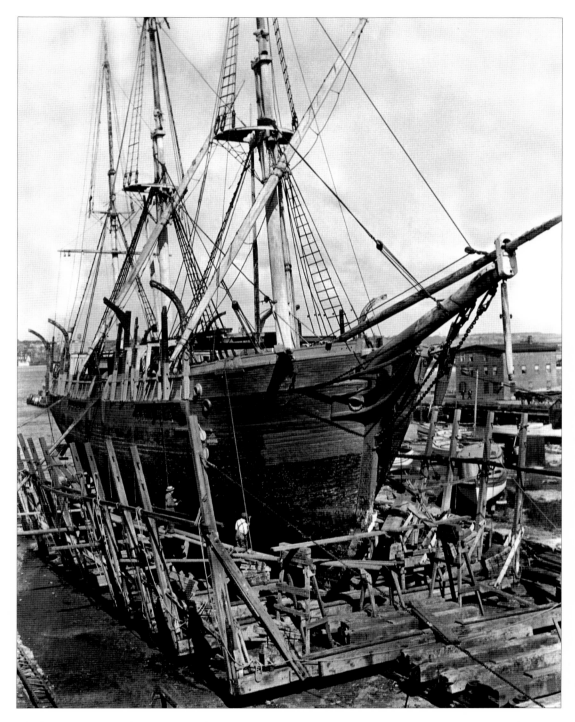

Charles W. Morgan on the Ways at Fairhaven Circa 1920
Albert Cook Church 3⅜" x 4" nitrate negative

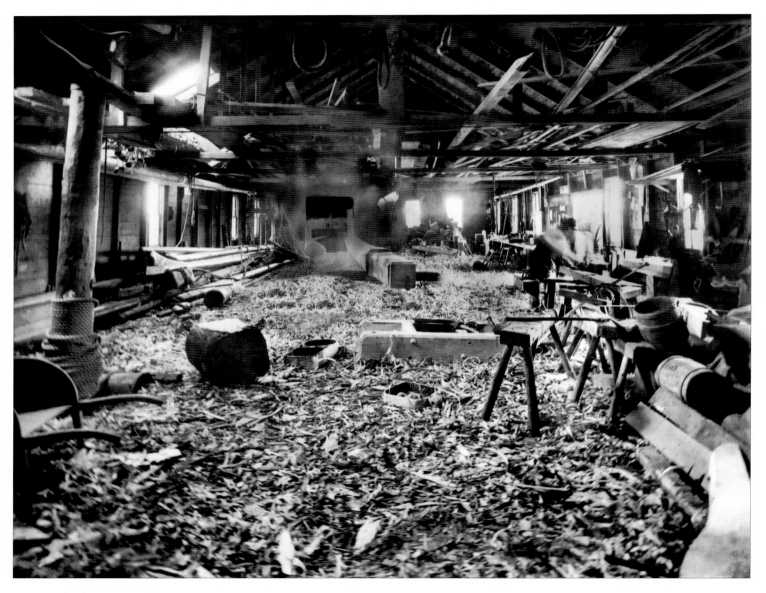

E. H. Howland & Son Spar Shop
Unknown

Circa 1885
4" x 5" dry plate negative

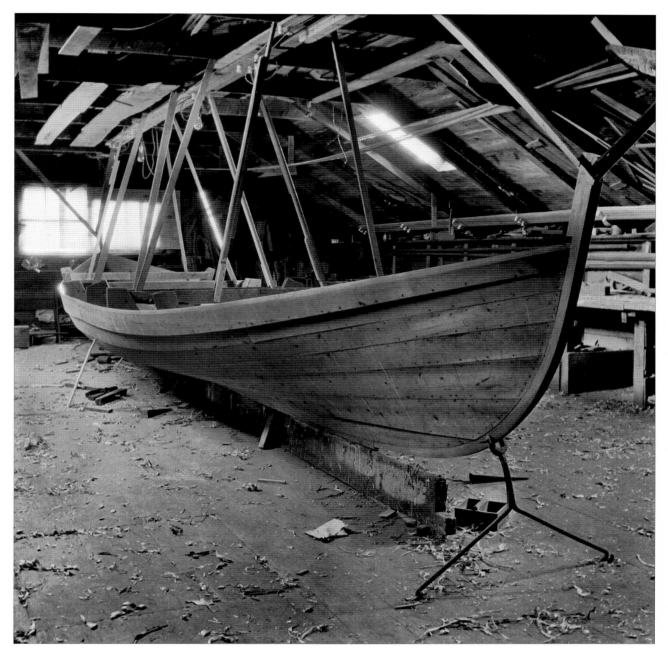

Whaleboat Planked-Up
Albert Cook Church

Circa 1905
3½" x 3½" nitrate negative

In the 1850s the demand for whaleboats had reached its peak. In 1858, New Bedford alone required 450 boats to outfit her fleet.

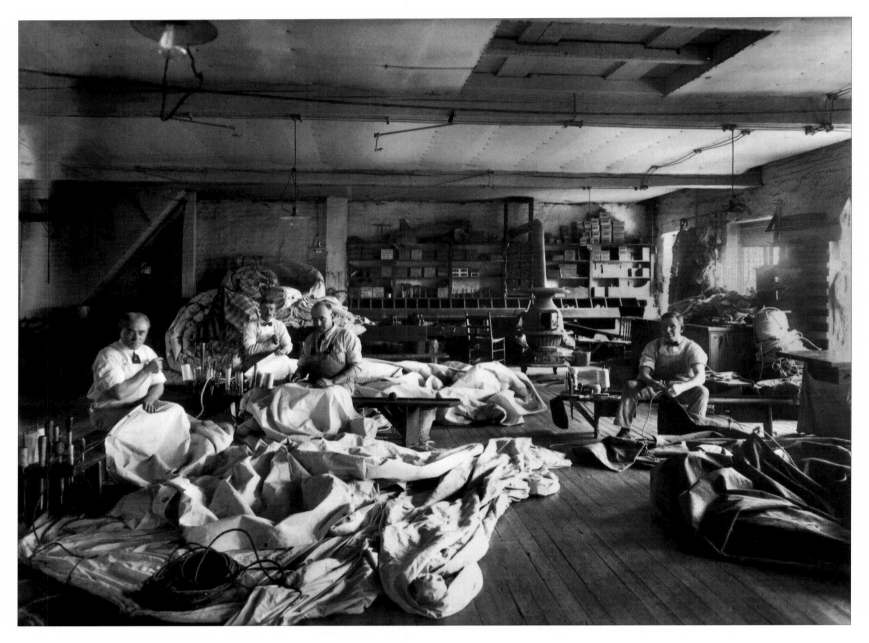

Briggs & Beckman's Sail Loft
Arthur Packard

Circa 1920
6½" x 8½" dry plate negative

A typical whaleship set hundreds of yards of canvas sail flying before the wind. Sails were hand sewn to custom specifications. Sail lofts were usually located on the top floor of a building where sailmakers could have large floor space on which to draw out their sail plans.

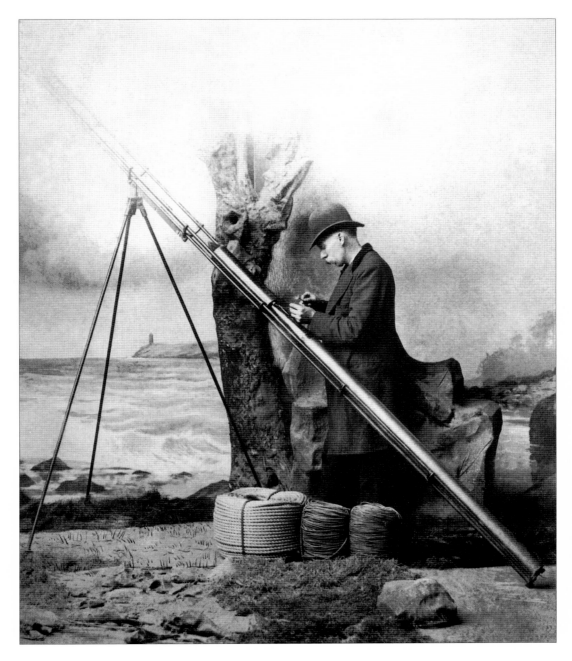

Patrick Cunningham and His Life Saving Rocket
John O'Neil

Circa 1889
8" x 10" albumen print

Cunningham, a local whalecraft manufacturer, turned his inventive genius to the production of a rocket designed to send a lifeline to stricken vessels within range of shore. Though not an original idea, Cunningham's version offered refinements which improved the feasibility of rescue rocketry. Staged in O'Neil's studio, this photograph shows the inventor uncomfortably close to the fuse with a lit match.

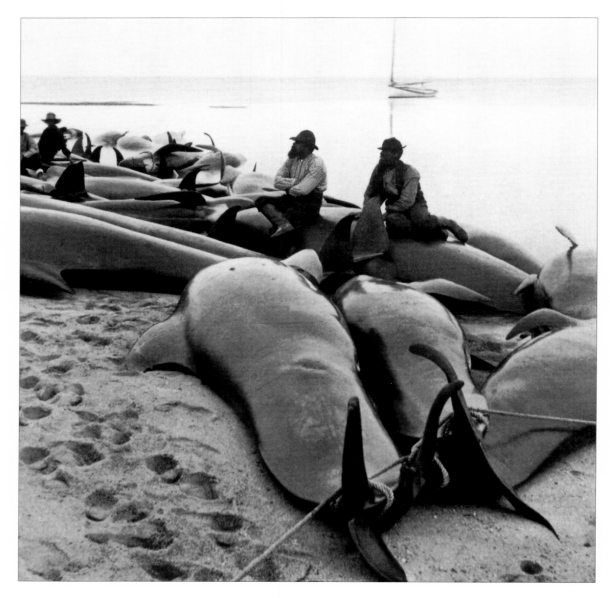

Blackfish Ashore at Nantucket Circa 1870
Josiah Freeman Stereograph

These small whales congregate along the shores of Cape Cod, Martha's Vineyard and Nantucket to feed on fish and squid.
When spotted near shore, men in small boats would get between the blackfish and deep water. By making noise they would
"gallie" or confuse the whales into beaching. The whales were then sold to William Nye's Oil Works in New Bedford.

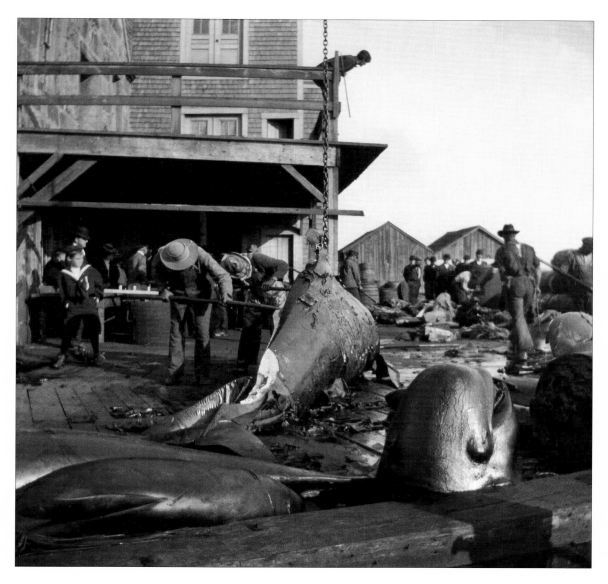

Nye's Oil Works
Albert Cook Church

Circa 1910
3½" x 3½" roll film

Blackfish were brought to Nye's Oil Works on Fish Island in New Bedford Harbor for trying out and further processing. Highly prized for lubricating fine machinery such as watches, clocks and chronometers, blackfish oil remains fluid at Arctic temperatures, a critical consideration for vessels dependent upon their navigational instruments in that climate. William Nye monopolized the oil which found use worldwide, including in the great astronomical clock of Strassburg Cathedral.

Shipwrights Repair the Pintles of a Rudder
Unknown

Circa 1890
Dry plate negative

82

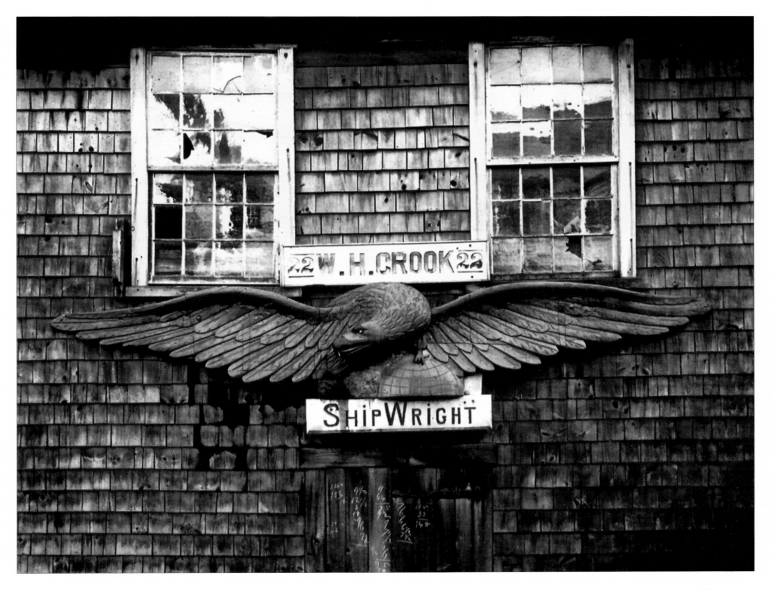

Bark *Atlantic* Sternboard at W. H. Crook's Shop
Joseph G. Tirrell

Circa 1900
8" x 10" gelatin/silver print

In 1900, the remains of New Bedford's once proud whaling fleet were still in abundance, including this spectacular 13–foot carved pine eagle nailed to W. H. Crook's shipwright shop. This eagle was carved in 1851 for the bark *Atlantic*.

The City

⤐

While the whaling industry declined, the medium of photography experienced steady improvements. As a result, much of the whaling legacy is preserved in photographs. Meanwhile, other industries sprang up in New Bedford as merchants sought new and more promising investment opportunities. In the last quarter of the nineteenth century the manufacture of fine cotton goods produced an era of prosperity that dramatically altered the appearance of the city. Large brick mill buildings of a scale previously unseen in New Bedford sprang up along the west bank of the Acushnet River in the north and south ends of the city. Block after block of three-decker tenements were built to house thousands of immigrant mill operatives and their families. What had been a compact seaport nestled on the hill between County Street and the river became a large industrial city. Coal pockets replaced the rows of whale oil casks along the waterfront, electric replaced gas lights, and horse-drawn vehicles gave way to street railways and automobiles.

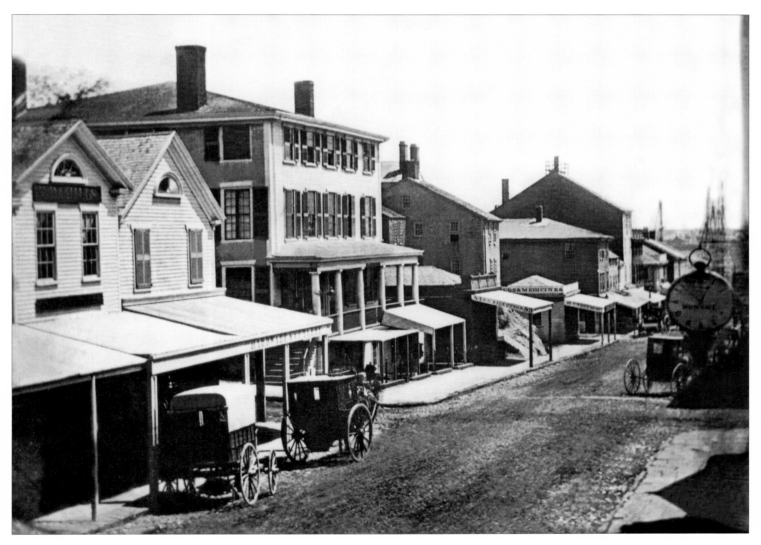

Lower Union Street

1849

Morris Smith

Daguerreotype

In 1849, Morris Smith changed his vocation from miniature painter to daguerreotypist. From the second story window of his studio he recorded the earliest known street views of New Bedford. This view shows the north side of Union Street, the city's business center, which included a shoe store, hardware store and apothecary. The large building with the column-supported porch was the Mansion House, a hotel, at the corner of Second Street. The original daguerreotype, though lost, was photographed and then printed.

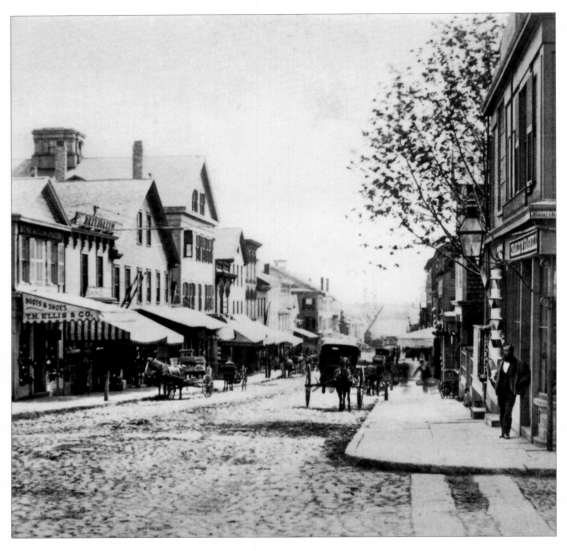

Union Street
Stephen F. Adams

Circa 1870
Stereograph

This view looks east down Union Street from Purchase Street. To the right, Charles Haskell stands in front of his hat and cap store.

Early stereographs were albumen prints made from wet plate negatives, a process that made exterior photography possible and profitable. Because multiple prints could be made from a negative, the photographer could sell the same view again and again. The result was a period of ten years, 1865–75, in which an extensive documentation of the city occurred.

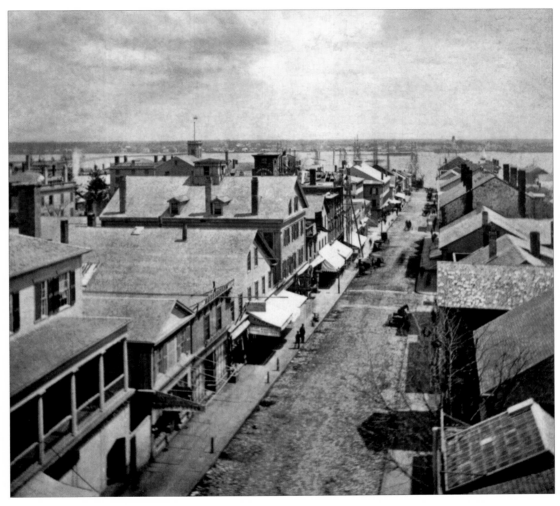

Birds-Eye View Down Union Street Circa 1870
Thomas E. M. White Stereograph

Thomas White made this view down Union Street from almost the same location as Adams in the previous view. While Adams worked at ground level, White found the elevated perspective of the Ricketson Building's third floor a more revealing vantage point.

Stereographs were made by a camera with two lenses, thus producing a negative with two nearly identical images adjacent to each other. The print, made on albumen paper, was mounted on a card, rougly 3" x 5", and intended for view through a stereoscope—a portable optical contraption that rendered the photograph in three-dimensional (hence, stereo) format. Because obtaining the stereo experience in printed form is impossible, most of the stereographs presented in this book show only one side of the stereo image. An entire mounted stereograph appears on page 11, and a contacted stereograph negative appears on page 152.

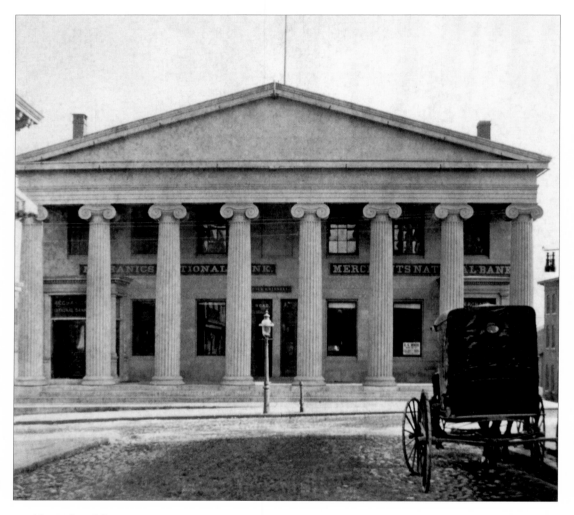

Double Bank Building Circa 1875
Noah Gifford Stereograph

Built in 1831 and designed by the well-known Rhode Island architect Russell Warren, this Greek Revival building
housed both the Merchants National and Mechanics National Banks. The building still stands on Water Street, at the
foot of William in New Bedford's Historic District.

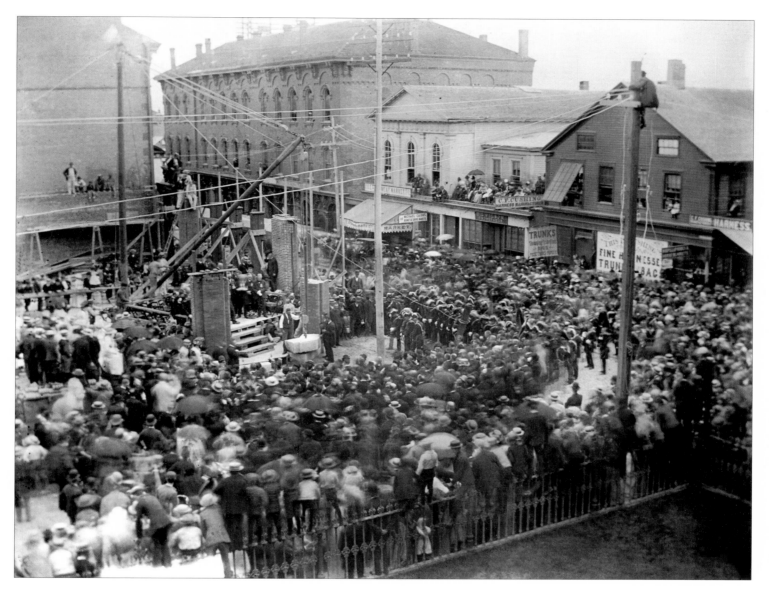

Laying the Cornerstone for the Odd Fellows Building, Pleasant and William Streets
Unknown

<div align="right">Circa 1890
4" x 5" dry plate negative</div>

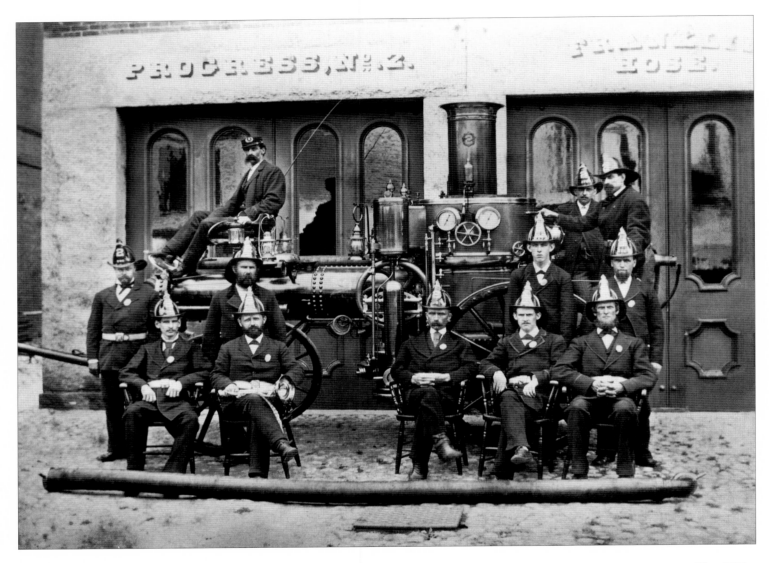

Progress No. 2 and Central Engine House
Unknown

<div align="right">Circa 1860
8" x 10" albumen print</div>

In 1859, the greatest fire in New Bedford's history began at the Wilcox Planing Mill and moved north along the waterfront, destroying numerous businesses and houses. It was stopped only by dynamiting a number of houses in its path. Within a few months, the steam pumpers *Onward No. 1* and *Progress No. 2* were added to the city force, replacing the hand pumpers used to fight the 1859 fire.

Central Engine House, Purchase Street and Mechanics Lane
E. Paul Tilghman

Circa 1885
4¾" x 6¾" printing-out-paper

The men of that noblest fraternity, the firefighters, never were bashful when it came to being photographed. Photographer Tilghman's wit is revealed in the arrangement of these firefighters, who seem more like tin soldiers than real men. Tilghman was one of two prominent African-American photographers in New Bedford. The other was James E. Reed.

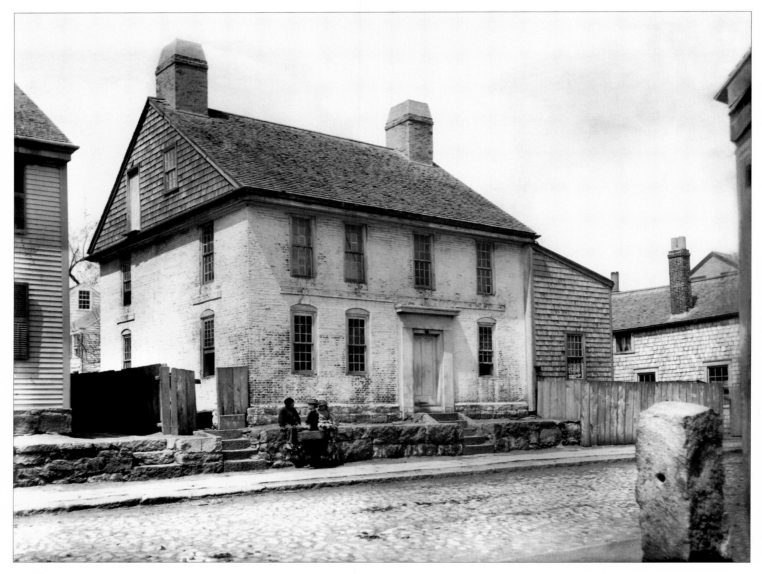

Hudson House Circa 1870
Thomas E. M. White 8" x 10" wet plate negative

Built in 1769 with bricks imported from England by bricklayer Edward Hudson, this house stood until the 1930s. Located on South Water Street, it was the first house in the New Bedford area with a chimney at each end and a central hall from front to rear.

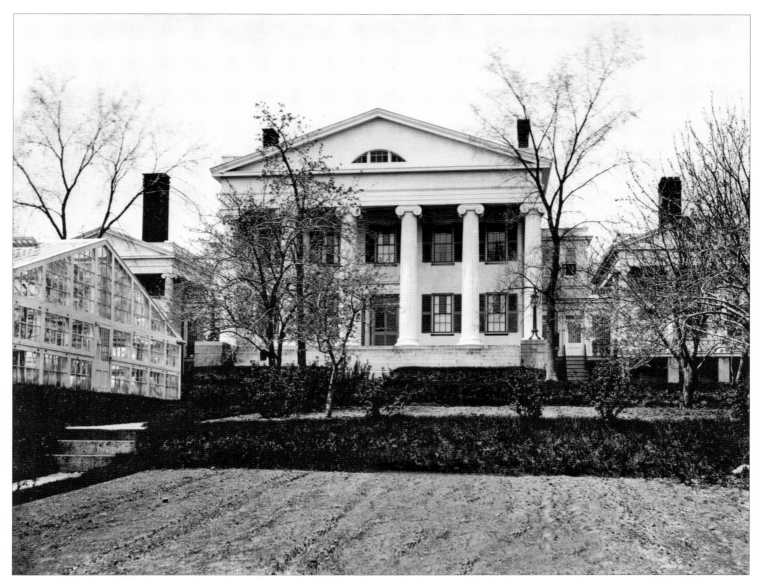

John Avery Parker Mansion
Thomas E. M. White

Circa 1870
8" x 10" wet plate negative

John Avery Parker, president of the Merchants National Bank, was New Bedford's first millionaire. In 1833, he commissioned Russell Warren to design a mansion that would reflect its owner's means. It was purported to be the largest Greek Revival residence ever built in the United States.

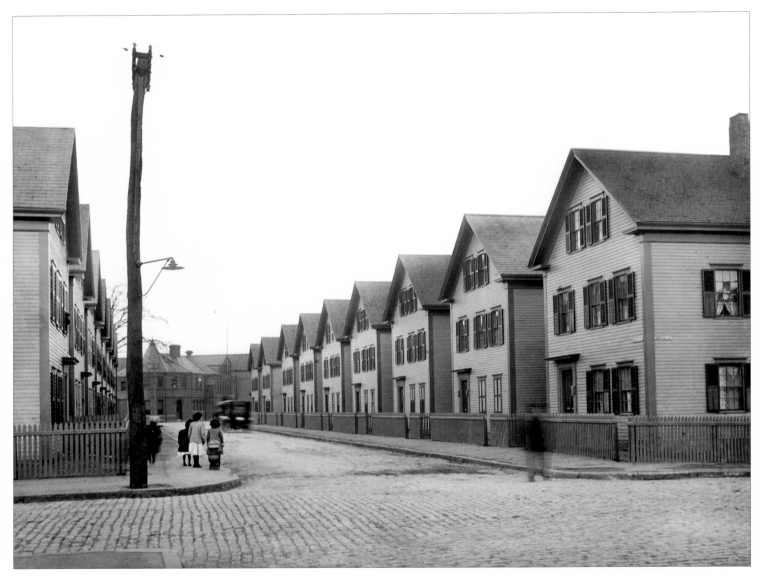

Grinnell Mill Housing, Logan Street
Edmund D. Ashley

January 1915
4" x 5" dry plate negative

Compact rows of houses were constructed to house the influx of laborers needed to work the city's expanding textile mills.

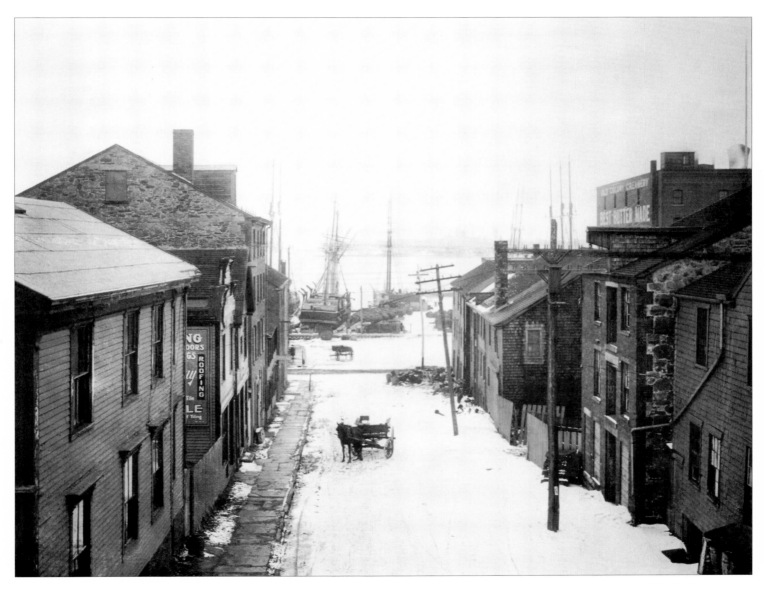

Center Street in Winter
Unknown

Circa 1910
8" x 10" gelatin/silver print

With the demise of the whaling industry, the waterfront and its adjacent streets went into hibernation. The one sign of life is carpenter D. L. Hathaway and Son's horse-drawn wagon.

County Street, North Between Russell and Bedford Streets
Joseph G. Tirrell

<div align="right">

Circa 1900
8" x 10 " dry plate negative

</div>

Large houses, spacious yards, iron fences, granite posts and tall elm trees contributed to the stately character of County Street, avenue of New Bedford's wealthy merchants.

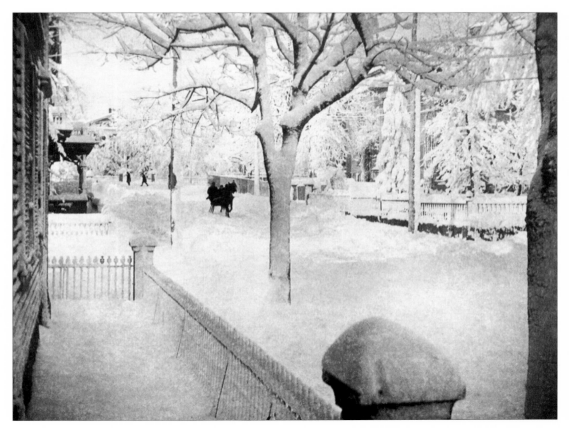

After a Snow Storm 1898
Dr. Henry Prescott 4" x 5" cyanotype print

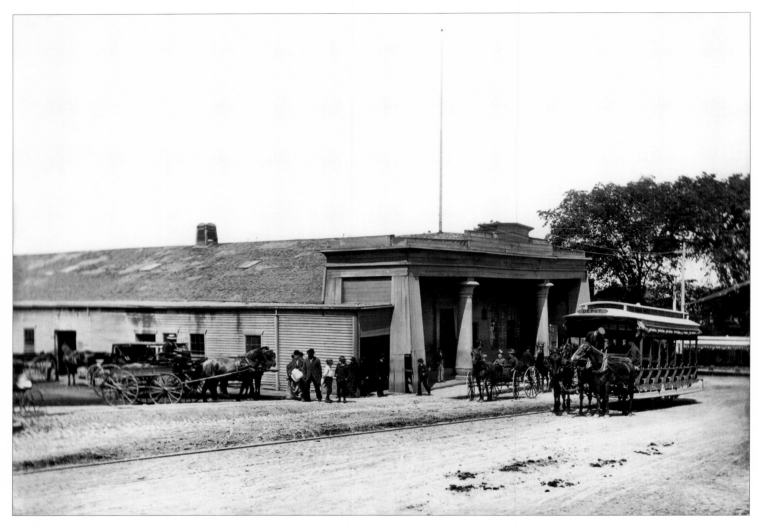

Pearl Street Depot

Henry P. Willis

Circa 1885

6½" x 8½" dry plate negative

Built in 1840 at the terminus of the New Bedford & Taunton Railroad, the depot served until it was replaced by a larger structure in 1890. Of Russell Warren's unusual design, the *Boston Atlas* wrote on July 2, 1840: "The car house and ticket office is built in the Egyptian style of architecture, with ends in imitation of the entrance of the catacombs, or the arches of gates. The appearance of the building is singularly odd and appropriate." Local residents called it "The Tombs."

Street Car Stuck in the Snow
Edmund Ashley

February 14, 1914
4" x 5" dry plate negative

"Worst Storm of the Winter Ties up City Traffic Badly," read the *Evening Standard* headline. The storm caught the motormen off guard: "…When the first cars, manned by brave souls in motormen's uniform, shoved their cars out of the barn ahead of the snow plows, instead of behind them, they began to encounter difficulties. The low fenders on the cars, made imperative by the state law, gathered all the snow up in front of them, and the cars…soon found themselves up against an insurmountable obstacle."

View South along South Water Street near Division Street
Joseph S. Martin

1924
8" x 10" nitrate negative

South Water Street was an important commercial district in a growing ethnic enclave of Portuguese, Jewish, French-Canadian, Polish, Irish and Lancashire immigrants. It ran between the textile mill complexes along the waterfront and blocks of three-decker wooden tenements where most workers lived.

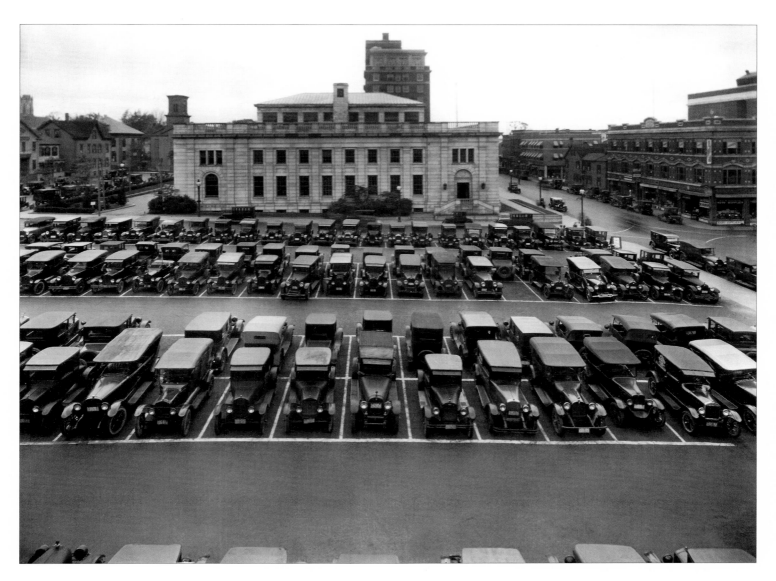

Municipal Parking Lot Circa 1924
Joseph S. Martin 8" x 10" nitrate negative

This view from a window in City Hall shows by strength of numbers how the automobile had quickly come to dominate the road.

The Bridge

~

*I*n 1800, a toll bridge between New Bedford and Fairhaven was opened by a corporation of local investors. Public transportation over the bridge did not begin until 1832. That year, Luther Wilson announced he would run a carriage hourly with one-way fare at eight cents.

The passenger ferry continued to be popular in spite of the bridge. Historian Daniel Ricketson summed up the sentiment held by some in 1858: "The bridge is still thought by many to be a great public damage. It is undoubtedly a great convenience on many accounts, but it is questionable whether it accommodates the public better than might be done by the ferry boats; and, that the value of our harbor as well as the beauty of the river, is much impaired by it, few will question."

After the Gale of 1869 destroyed the bridge, a toll-free bridge was completed in 1870. The *Evening Standard* described it as "a pretty sight. The bridge is now lit up in the evening its entire length. The travel is large, especially in the evening, our citizens availing themselves of the cool breezes and the beautiful prospect." The wooden bridge was replaced in 1898 by a steel structure which still stands today.

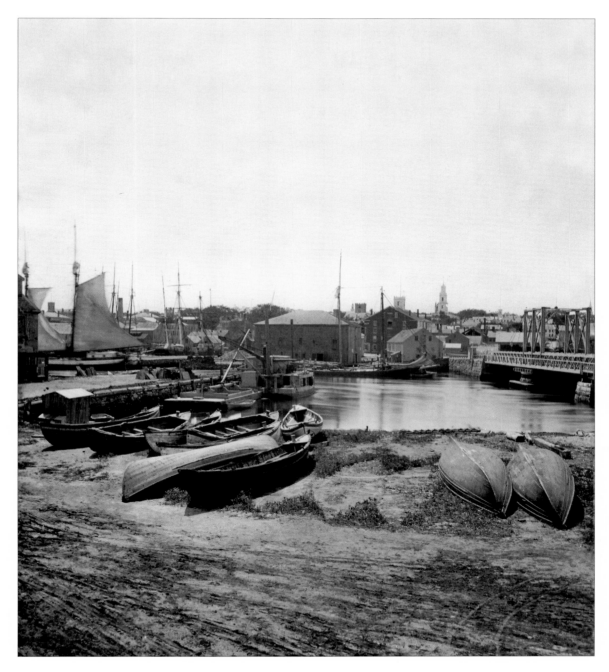

Whaleboats at Fish Island, First Turntable Bridge on Right
Stephen F. Adams

Circa 1870
Wet plate/stereograph

New Bedford and Fairhaven Bridge West Approach March 5, 1895
Clifford Baylies 8" x 10" cyanotype print

The old toll booth, which served the earlier bridge, can be seen on the right behind the man walking. The toll collector also acted as bookkeeper and took care of bills for snow removal, repairs, painting, and printing tickets. The average toll receipts in 1866 came to $450 per month.

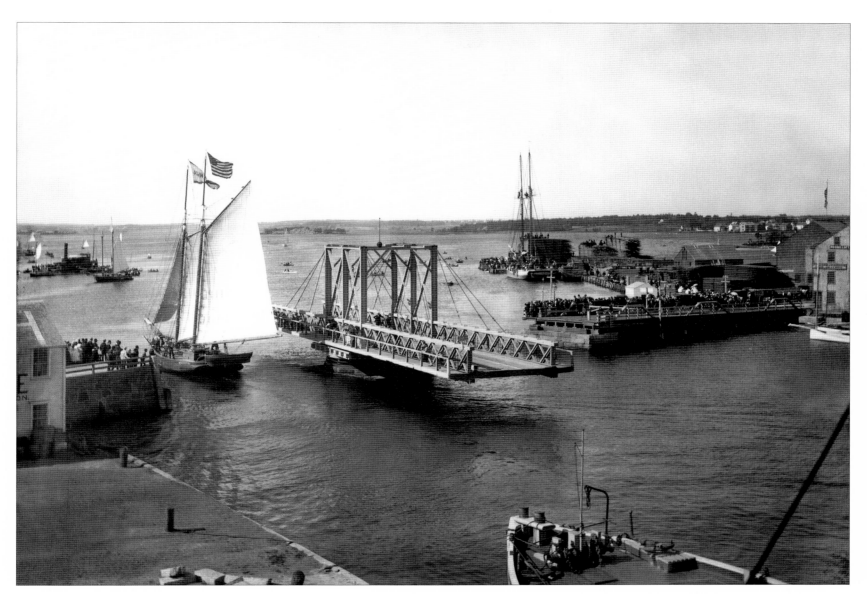

Schooner Passing through the Draw July 4, 1888
Henry P. Willis 6½" x 8½" dry plate negative

A big crowd is on hand to watch the boat races held north of the bridge during the Independence Day celebration of 1888. Riding a southwest breeze, a schooner has just passed through the bridge, causing a horse-and-buggy traffic jam.

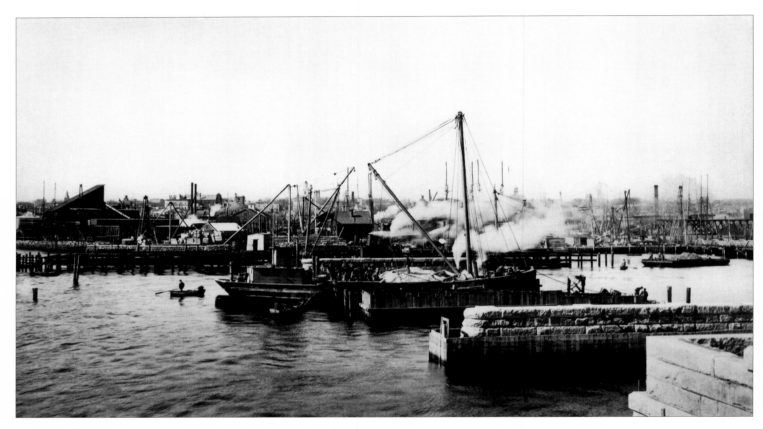

Construction Progress
Clifford Baylies

Spring 1897
5" x 8" cyanotype print

The stone pillars used in the 1897-98 rebuild are far more substantial than the wooden pilings they replaced. This view looks west toward New Bedford.

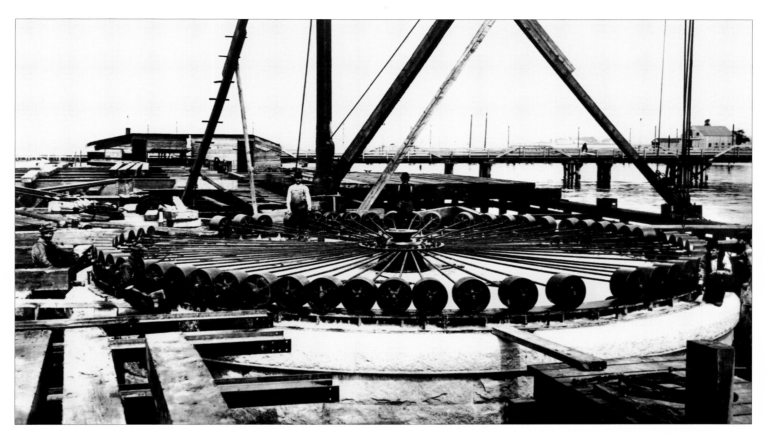

Installing the Hydraulic Draw for the New Bridge
Clifford Baylies

September 17, 1898
5" x 8" cyanotype print

Clifford Baylies made hundreds of photographs of the bridge before, during and after replacement of the span in 1897-98

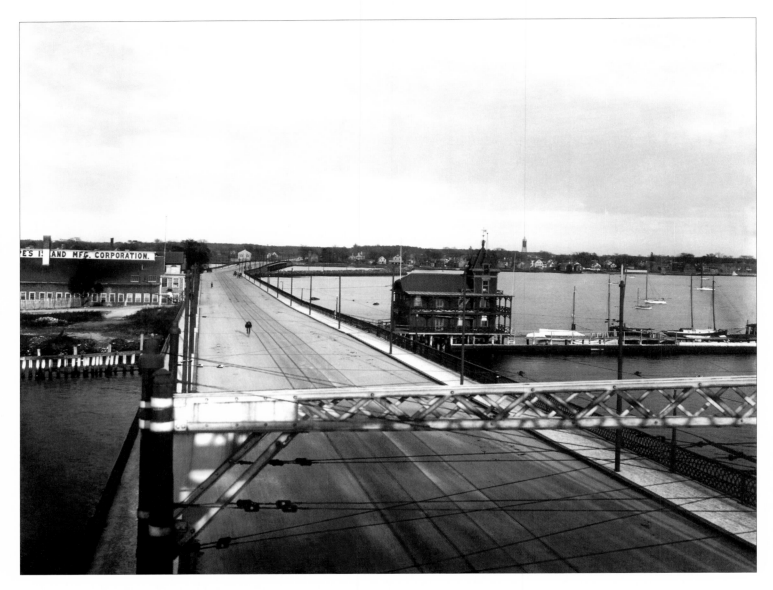

New Bedford and Fairhaven Bridge, Draw Construction Complete
Joseph G. Tirrell

<div align="right">

Circa 1905
8" x 10" dry plate negative

</div>

Atop the bridge erection, Tirrell looks east toward Fairhaven. At the right, on Popes Island, the New Bedford Yacht Club is perched on pilings overlooking the harbor. The club remained here until the 1938 hurricane pounded it into kindling.

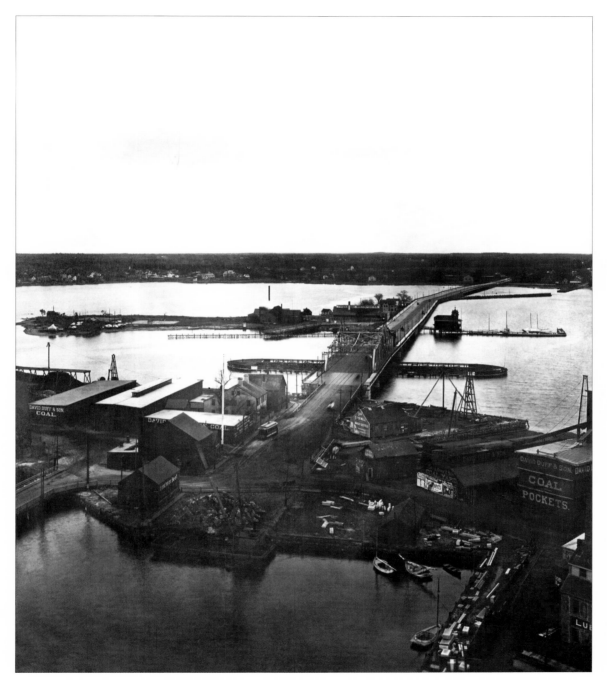

View East toward Fairhaven, Fish Island in Foreground
Joseph G. Tirrell

Circa 1900
8" x 10" gelatin/silver print

Only the west approach, connecting Fish Island with the mainland, is needed to complete the bridge.

Inhabitants

~

Until the coming of photography, very few people could afford to have their portrait rendered. In the nineteenth century, photographers did an enormous volume of portraiture, much of which has survived. As photography moved outdoors, newspapers, magazines, and other media adopted its use to illustrate the news and tell the story of everyday life. Photojournalism and documentary photography became important occupations.

The collection on the following pages shows prominent people, shipbuilders and literary celebrities as well as common citizens. Also included are two photographs from New York photographer and social reformer Lewis Hine, who visited New Bedford and Fall River in 1911, 1912, and 1916. Commissioned by the National Child Labor Commission to photograph the horrors of child labor, Hine left a rare legacy of images portraying children at work and the living conditions of many Americans. This series is housed in several archives including the Library of Congress.

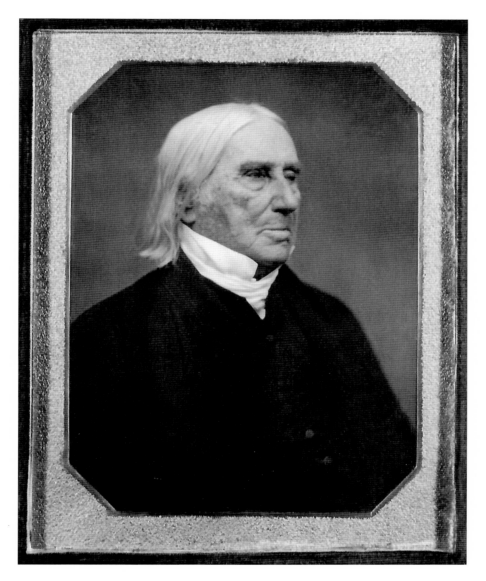

William Rotch, Jr. Circa 1845
Unknown ½ plate daguerreotype

William Rotch, Jr. was a prominent New Bedford citizen. Merchant, banker and manufacturer
were some of the roles Rotch had filled as he approached his 90th year.

Zachariah Hillman, Jr. Circa 1842
Unknown ¼ plate daguerreotype

Shipbuilders Zachariah Hillman, Jr. and brother Jethro launched 17
large vessels from their New Bedford shipyard between 1826 and 1852,
including the whaleship *Charles W. Morgan* on July 21, 1841.

Nancy Slocum Circa 1850
Unknown ¼ plate daguerreotype

Dead Child Circa 1845
Unknown ⅙ plate hand-colored daguerreotype

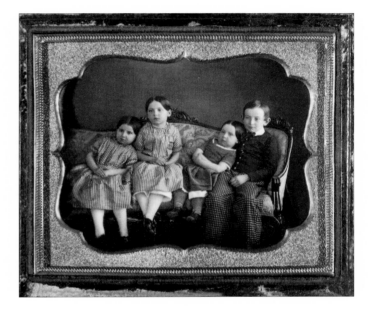

Four Children Circa 1850
Unknown ⅙ plate daguerreotype

The daguerreotype was named for Louis Daguerre, the Parisian who introduced photography to the world in 1837. Daguerreotypists practiced in New Bedford as early as 1841 and operated for about 15 years. Making daguerreotypes was a slow and complicated process. The emulsion was a thin mercury compound which was layered on a polished silver plate. Because the daguerreotype was exposed directly in the camera, it was a mirror image. One exposure yielded one image and no copies could be made from the image. Daguerreotypes were sold in a velvet-lined, book-like case, with a brass frame and glass cover. By the late 1850s, the daguerreotype was succeeded by similar, less expensive and less fragile methods producing ambrotypes and tintypes.

 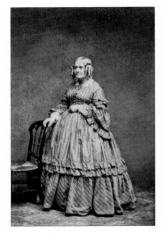 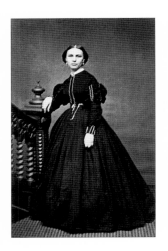

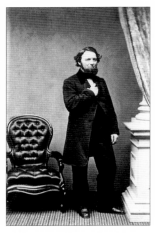 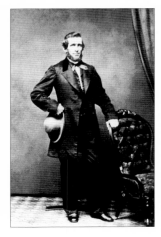 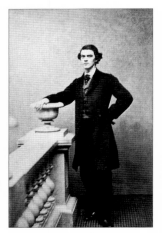

Residents in Formal Attire
Various New Bedford Photographers

Circa 1865
Carte de visites

Beginning in 1859, the Bierstadt Brothers offered small, card-mounted paper prints made from a negative, called carte de visites. Other studios soon followed practice and for the first time, multiple identical prints could be produced for considerably less than the daguerreotype or the ambrotype. Carte de visites were greeted enthusiastically. Family albums were established and the cards were distributed to family and friends.

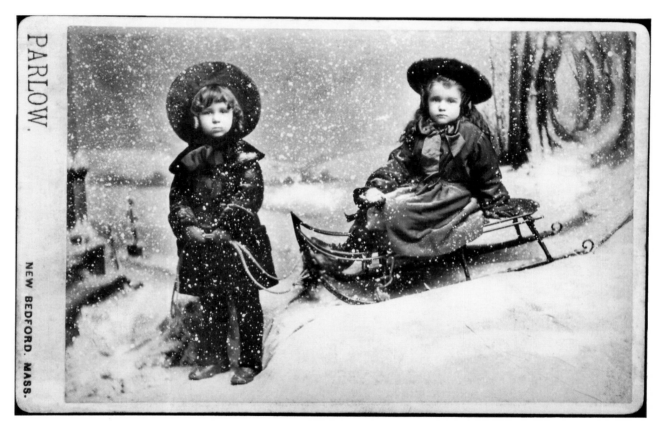

Two Girls in a Blizzard Circa 1880
George Parlow Cabinet card

This winter scene was concocted in the studio and darkroom of George Parlow. The girls were photographed against a painted backdrop and the falling snow was splattered onto the negative before printing.

By the 1870s the momentum of the carte de visite craze was subsiding. In its place came a new version of the card-mounted portrait, the cabinet card. At 4¼" x 6½", cabinet cards were larger in size and, in making them, photographers often used props, backgrounds, and costumes to outrageous extremes, particularly when photographing children.

"The Letter," Annie Amelia Nye Swift Circa 1890
Clement Nye Swift 5" x 8" cyanotype print

In a sun-drenched room, a young woman in a white dress looks up from the letter she holds. Her contemplative expression does not betray the letter's message. Tidings from a friend or lover? We wonder. This little drama was carefully staged by Acushnet painter Clement Nye Swift, who often signed his photographs "Chung."

Daniel Ricketson July 30, 1897
Unknown 4¾" x 7" platinum print

Historian, poet, abolitionist, Daniel Ricketson was an intimate of New England's literary giants including Thoreau, Channing, Alcott and Emerson.

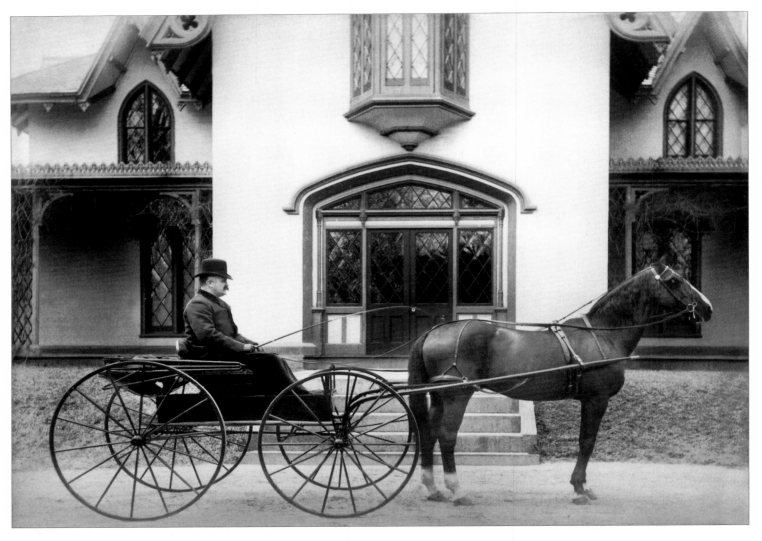

Morgan Rotch
Unknown

Circa 1885
6½" x 8½" albumen print

Morgan Rotch was a broker, cotton mill director, state senator and mayor of New Bedford between 1885 and 1888. Reflecting his interest in spirited horses, Rotch chose to be portrayed at the reins of his buggy in front of his Gothic cottage.

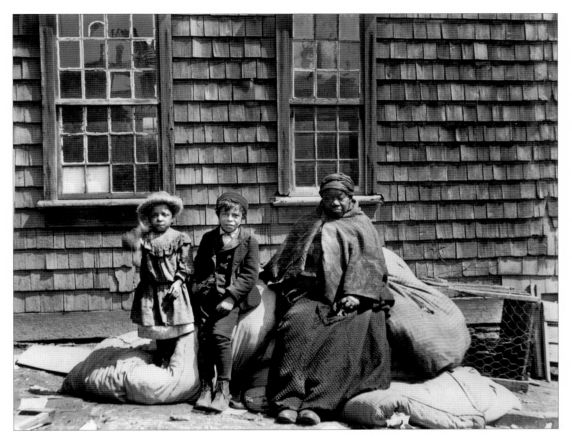

Mrs. Mann and Children 1905
Fred Palmer 4" x 5" dry plate negative

Henry B. Worth described the unfortunate circumstances surrounding this picture in *Photographs Of Old Dart-mouth:* "For many years before its removal, the John Howland house was occupied by colored people. When the property was purchased by the Fall River Cotton Brokers, they ordered the tenant Mrs. Mann to vacate. She refused and they proceeded to demolish the house. They took out the windows and doors and had begun to tear down the chimney when she decided that it was time to move. This picture represents the last of her household effects while she was waiting for a vehicle to transfer them to another part of the city."

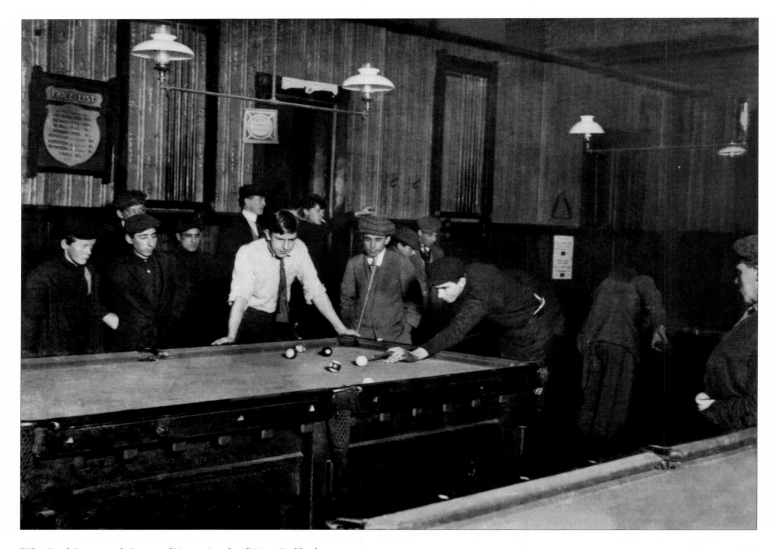

"Elm Pool Room and Group of Young Loafers," New Bedford
Lewis W. Hine

January 1912
5" x 7" gelatin/silver print

Hine traveled across the country working for the National Child Labor Commission, hoping to induce lawmakers to abolish child labor by publicizing its wretchedness. When not in and around the area's textile mills, Hine often spent time on the streets photographing young people hanging around instead of being in school. "He knows saloon life, he gambles, he wastes his money…"

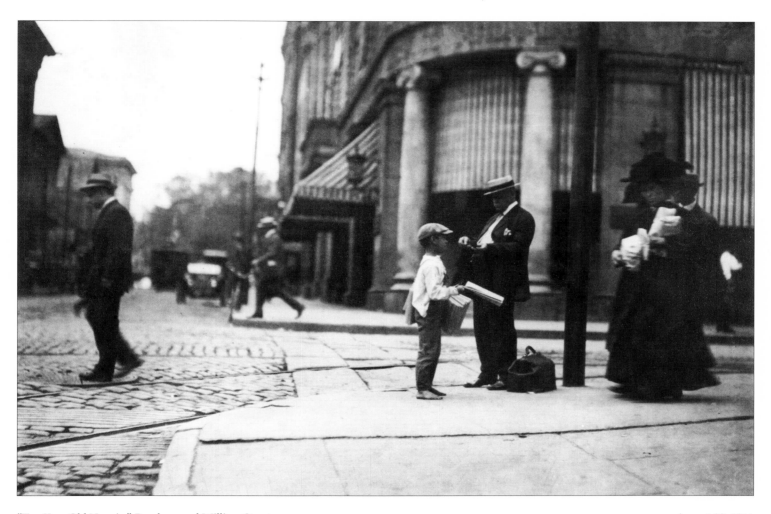

"Ten Year Old Newsie," Purchase and William Streets
Lewis W. Hine

August 22, 1911
5" x 7" gelatin/silver print

"Note absence of badge or indication of regulation," noted Hine for this photograph. Concerned with the plight of young newsies and messengers in American cities, Hine attacked employers for hiring children illegally, and for working conditions that had them up at 4:00AM, working late at night, and often losing money in their work. "Every child should work," he wrote on posters displaying his haunting photographs, "but the work must develop not deaden." And another reads: "The child in the factory drives the father into the breadline…Overworked children become undeveloped men."

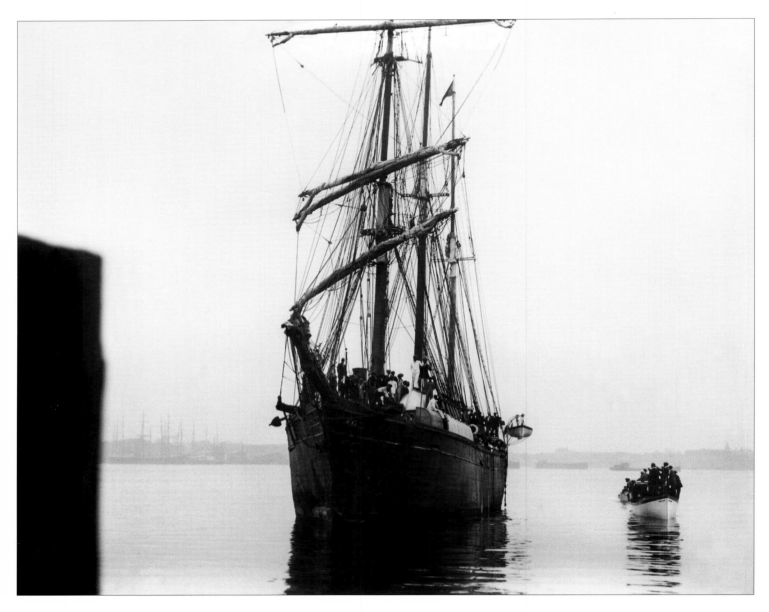

Savoia Arrives October 5, 1914
Edmund Ashley 4" x 5" dry plate negative

The *Savoia* arrived in New Bedford harbor after a 45-day passage from Fogo, Cape Verde Islands with 155 passengers and 28 crew members. While the ship dropped anchor outside of quarantine, as many as 100 pleasure crafts sailed around her to see who was on board from the islands. There was much conversation and waving of handkerchiefs.

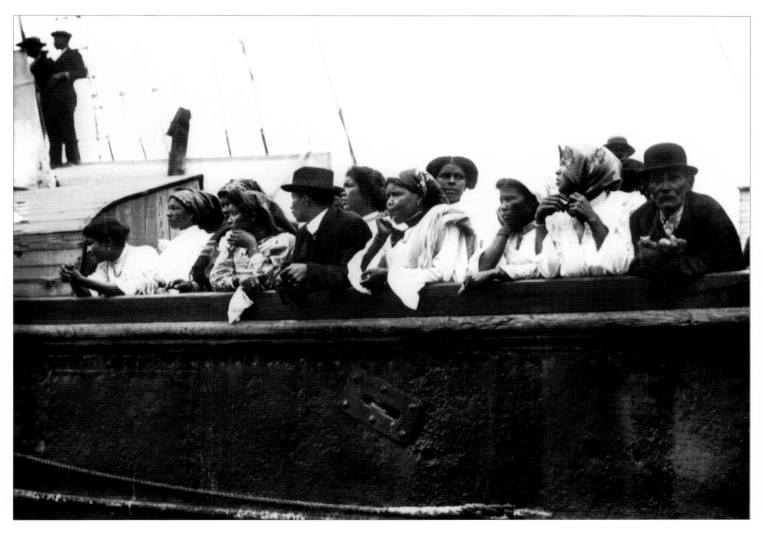

Savoia Arrives
Edmund Ashley

October 5, 1914
4" x 5" dry plate negative

Cape Verdeans initially came to New Bedford in small numbers as crew on whaling ships. From the turn of the century to the 1930s the Cape Verdean packet ships, which included schooners, barks and steamers, made hundreds of trans-Atlantic voyages bringing thousands of immigrants from Cape Verde to settle in southeastern New England.

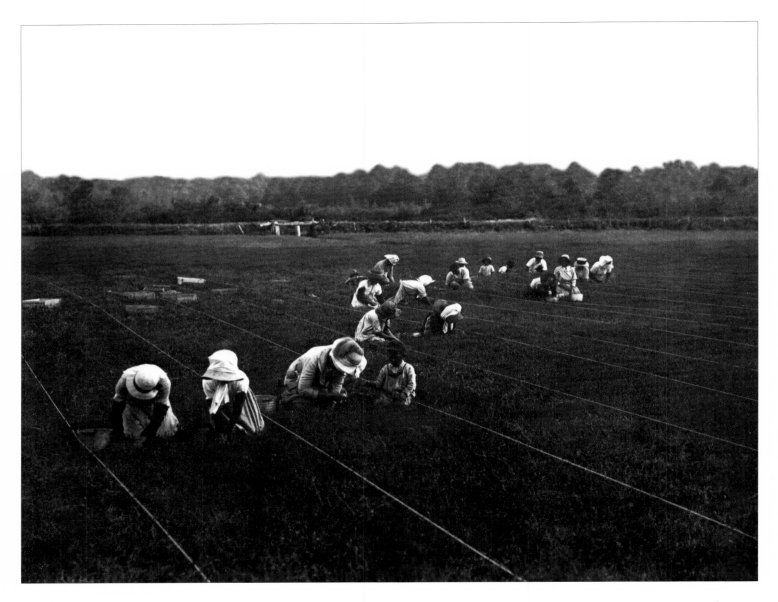

Cranberry Pickers
Edmund Ashley

September 1916
4" x 5" dry plate negative

Cape Verdean immigrant workers harvest cranberries for $3 a day in the town of Freetown at Nathaniel Sowle's bog. With the decline in the whaling industry, many Cape Verdean immigrants became workers on the Rochester, Wareham and Cape Cod cranberry bogs.

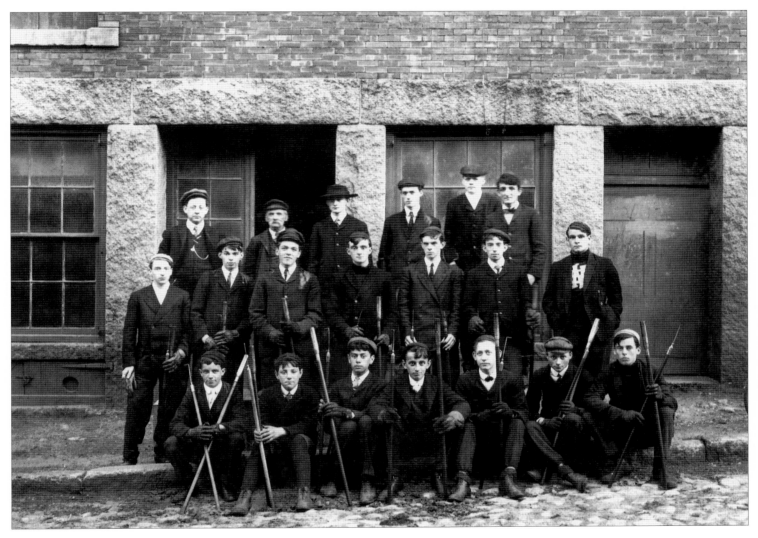

Lamplighters
Joseph G. Tirrell

September 1904
8" x 10" gelatin/silver print

These high school boys earned $4.26 a week tending the gas lamps illuminating New Bedford's streets. Twice daily they tended between 50 and 70 lamps each, lighting them in the evening and snuffing them out at dawn.

Industry

❧

After 1857, whaling in New Bedford suffered from both the effects of the Civil War and the discovery and use of petroleum products. Investors moved capital generated from whaling into other areas, most notably manufacturing. Small companies such as Brownell Carriage Manufacturing Company, the Taber Art Company, and the Snell Simpson Biscuit Company expanded. In the 1860s, industries such as the Taunton New Bedford Cooper Company, Morse Twist Drill and Machine Company, and New Bedford Glass Company were organized.

It was cotton textile manufacturing, however, that would dominate New Bedford. The industry flourished, beginning with the establishment of Wamsutta Mills in 1849. By 1920, at the height of the industry's prosperity, New Bedford had become one of New England's great mill towns, and was known around the world for its production of fine and fancy cotton goods. Only Fall River and Lowell boasted more spindles in operation than New Bedford.

The city's textile industry employed 41,380 operators at its peak in 1920, yet comparatively few photographs exist of New Bedford's mill interiors or the workers at their posts, especially prior to 1900. The mills were a separate world where management controlled everything. Perhaps fear of industrial espionage might have inspired secrecy. More likely, few photographs exist because there was no reason to commission pictures of immigrants and children working on dangerous machines. Such pictures could only lead to trouble from the outside.

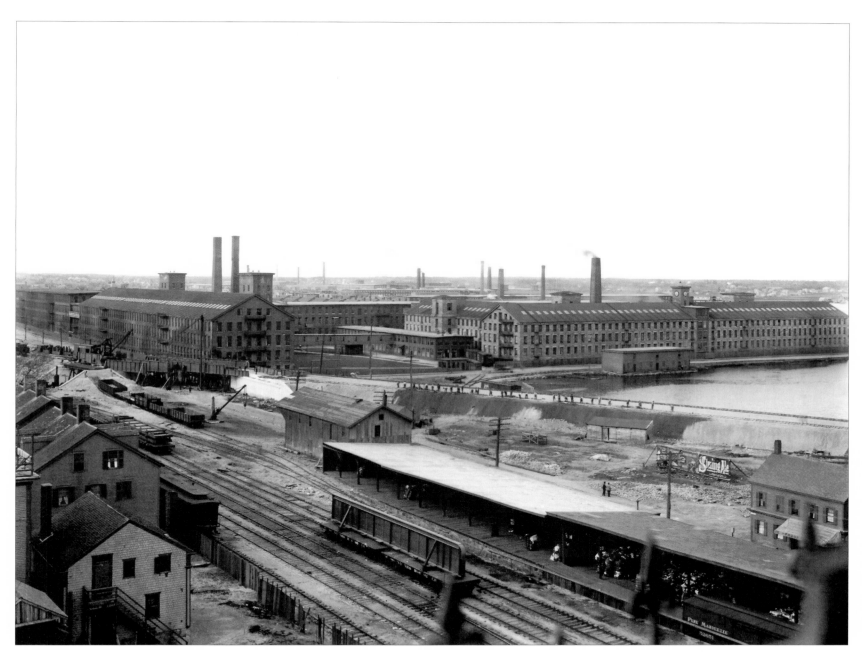

Wamsutta Mills Circa 1895
Joseph G. Tirrell 8" x 10" dry plate negative

Tirrell sought out this elevated vantage point to illustrate Wamsutta's six-mill complex. Behind Wamsutta, rooftops of tenements and mill buildings huddle on the Acushnet River's western shore. The horizon is occasionally broken by smokestacks from coal-fired steam engines powering mill machinery. In the foreground, bales of raw cotton have been off-loaded into the railroad yard's depot shed. Along the tracks a labor gang constructs an elevated crossing. Sections of the bridge sit on flatbed cars awaiting installation.

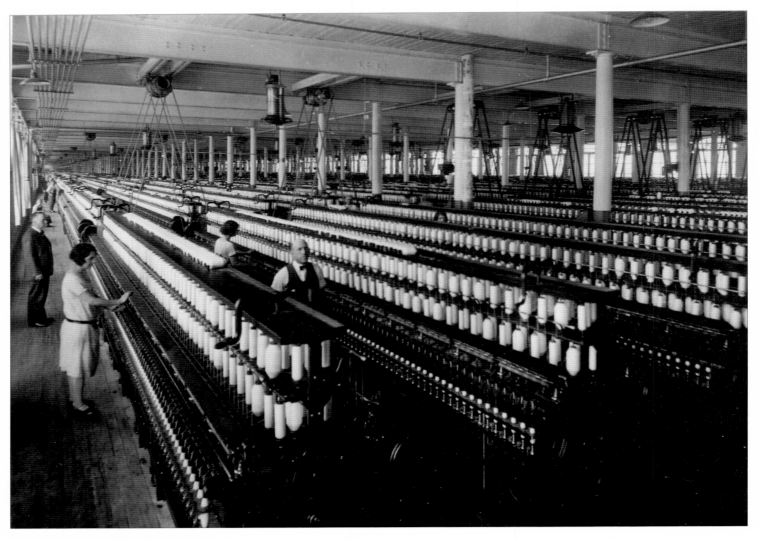

Spinning Room, Nashawena Mill
Unknown

Circa 1924
5" x 7" dry plate negative

In the huge spinning room of the Nashawena mill, a young spinner works as the dutiful overseer lingers behind her and the second hand paces in the next aisle. The Nashawena was renowned for having the largest weave shed in the world. It also claimed to have a yarn-spinning department that was "the most extensive in the country."

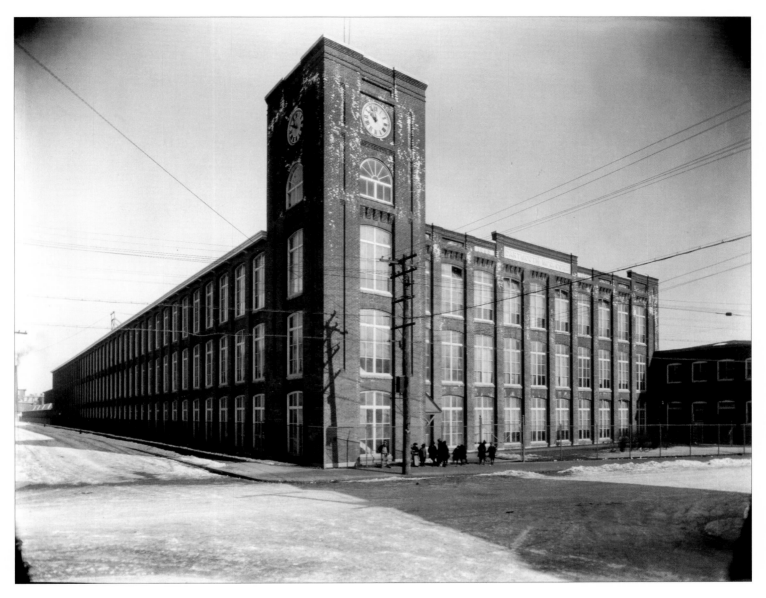

Dartmouth Manufacturing Corporation
Joseph S. Martin

Circa 1920
8" x 10" nitrate negative

The enormity of New Bedford's mill structures proved a challenge to photographers interested in architecture. In order to keep the vertical lines of the building parallel, a bellows camera with a tilting front and back was used. Here, Joseph Martin contrasts the children and their sleighs against the massive brick edifice, perhaps creating a metaphor of the industrial age where the worker, bound to the clock, was a simple extension of the factory's machinery.

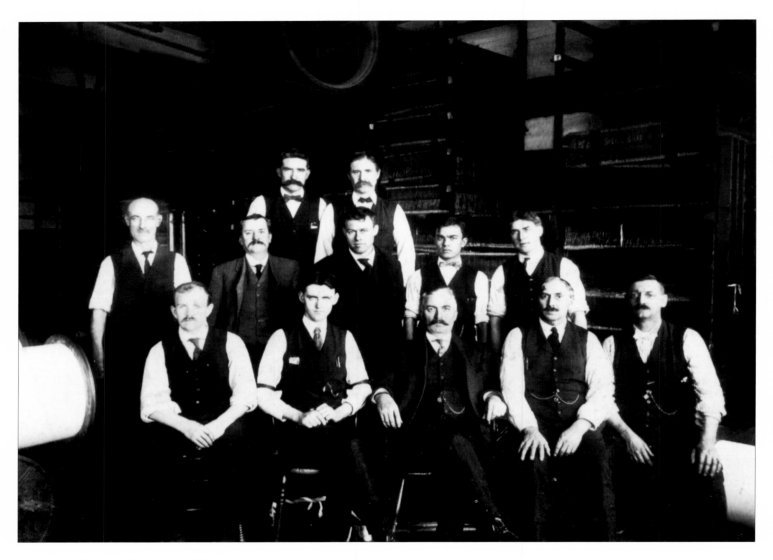

Management Personnel, Wamsutta Mills
Unknown

Circa 1910
5½" x 8" printing-out-paper

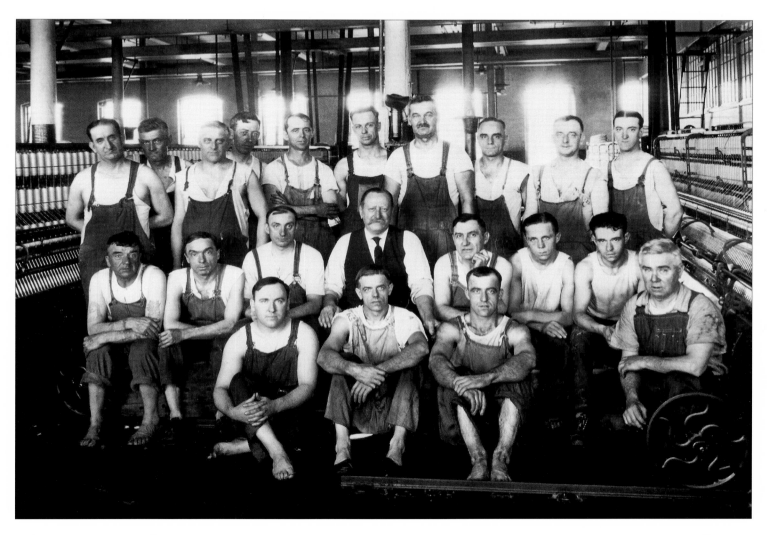

Mulespinners, Wamsutta Mills
Unknown

Circa 1910
6½" x 8½" gelatin/silver print

Among the most skilled laborers in the textile mill were the mulespinners. They operated the mule which spun delicate yarns essential for the fine material produced by Wamsutta.

New Bedford Cordage Company
Joseph G. Tirrell

Circa 1880
8" x 10" dry plate negative

The New Bedford Cordage Company was established in 1842. In addition to supplying rope to the many ships that fit out in this port, the company boasted the manufacture of rigging for the 1885 America's Cup defender *Puritan* and other racing yachts. This view of the ropewalk shows the rope laying machine. As it moved down the track it would assemble the strands and lay down the rope.

Brownell Hearse Model #46 1865
George F. Parlow 4" x 5½" albumen print

George Brownell came to New Bedford from a West-port farm and apprenticed himself to Ayres R. Marsh for four years before beginning his business. His success allowed him to purchase the Leonard's Oil Works building in 1863. With up to 100 employees, Brownell manufactured sleighs, carriages and hearses. In a prophetic, if not macabre business move just prior to the outbreak of the Civil War, Brownell offered hearses as a new line. These were to be a big seller throughout the United States and abroad.

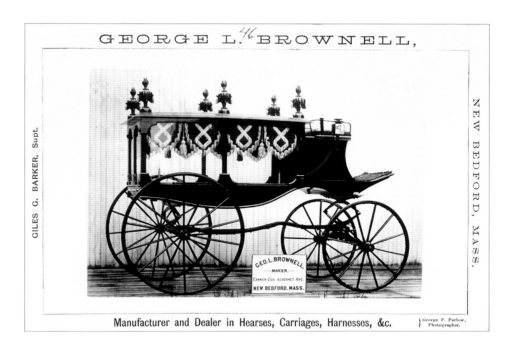

Brownell Carriage Manufacturing 1865
Bierstadt Brothers Carte de visite

This carte de visite, showing the plant and some of its products, was used as a business card.

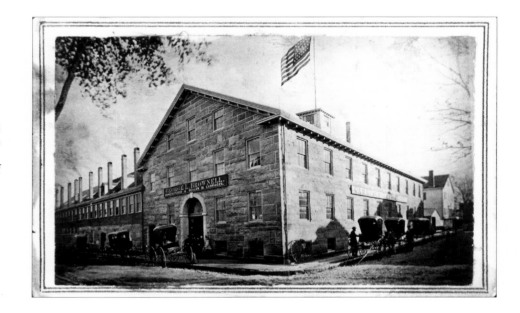

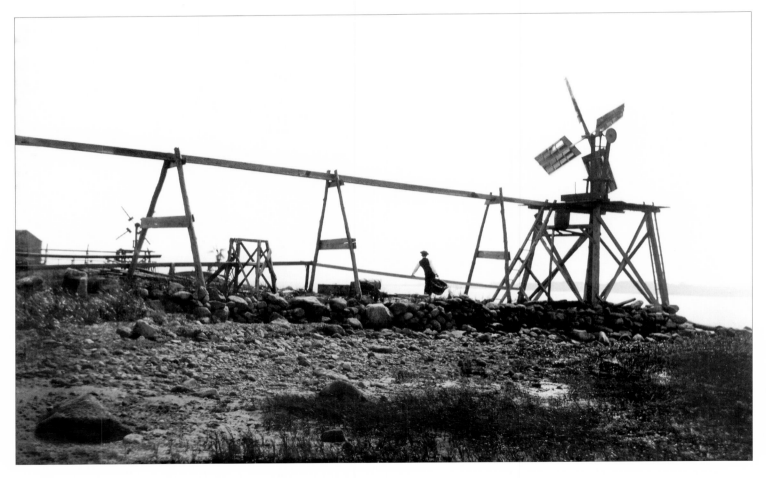

Windmills
Clifford Baylies

Circa 1895
5" x 8" dry plate negative

Saltworks were a common nineteenth century coastal industry. The process was simple. Sea water was pumped by windmills into a series of shallow canals or evaporating trays and the wind and sun evaporated the water, leaving the salt behind. In a bumper year the Howland works at Padanaram in South Dartmouth collected 14,000 bushels of salt. The smaller of the two saltworks at Padanaram was located on Ricketson's Point. In this view, the windmills are turning, pumping seawater up so that it will flow down the chute into the evaporating trays.

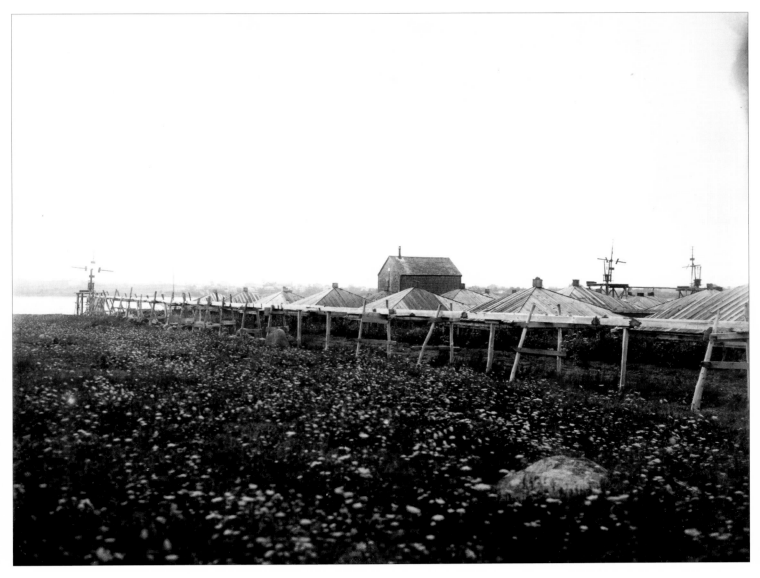

Saltworks at Ricketson's Point, Padanaram
Joseph G. Tirrell

Circa 1890
8" x 10" dry plate negative

Wooden covers protected the sluice ways and evaporating trays from the rain water.

Surrounding Townships

The colonial town of Dartmouth, referred to as *Old Dartmouth*, was divided into Fairhaven, Acushnet, New Bedford, Dartmouth and Westport. The setting was rural in these towns, and peoples' lives were sustained by farming, fishing, shipbuilding, lumbering and cottage industry. The countryside and villages were recorded by New Bedford photographers in excursions to the country, and less frequently by the local people themselves.

Much of Old Dartmouth consists of cedar swamps, marshes and wetlands that feed several rivers and esturaries. Among these are the Acushnet and Paskamansett rivers, two branches of the Westport River, Apponagansett Bay and the Slocum River estuary. Early in the region's development, bridges were erected across these sites, and were often the town's most accomplished engineering feat. Bridges were also favorite subjects for area photographers, particularly the graceful two-arched stone bridges on the Paskamansett and Acushnet rivers.

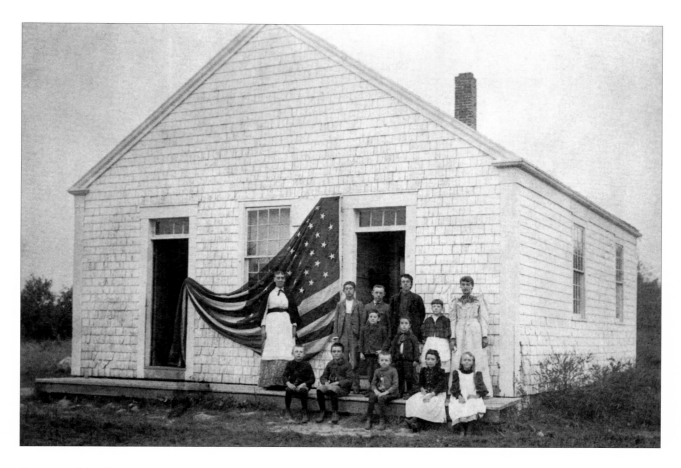

One Room Schoolhouse
F. E. Janson

Circa 1880
4¾" x 6¾" albumen print

Although the exact location of this schoolhouse is unknown, it is believed to have stood in Westport.

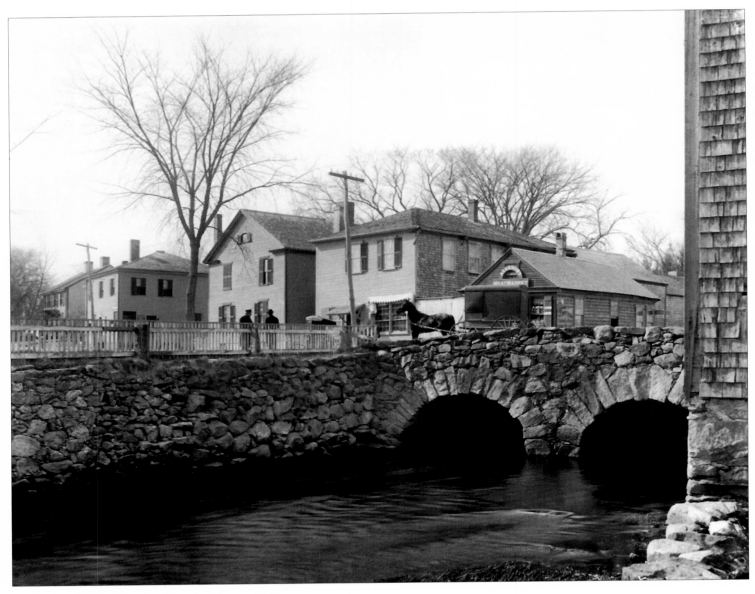

Bridge at the Head of the Acushnet River, New Bedford Side
Joseph G. Tirrell

Circa 1895
8" x 10" dry plate negative

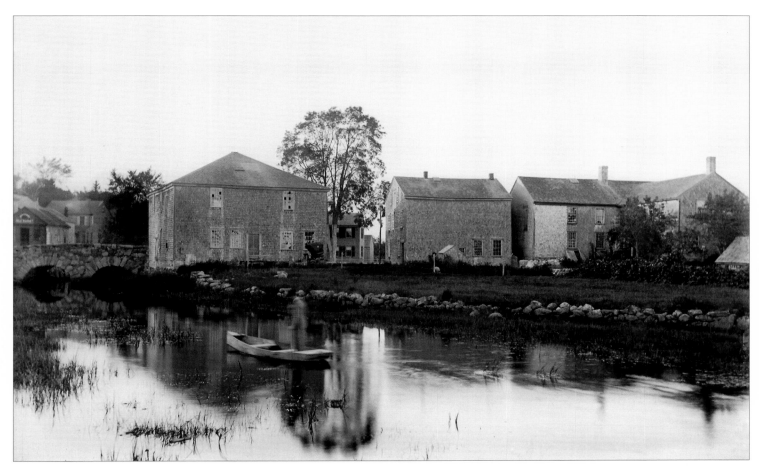

Head of the Acushnet River, Acushnet Side
Clement Nye Swift

Circa 1890
5" x 8" dry plate

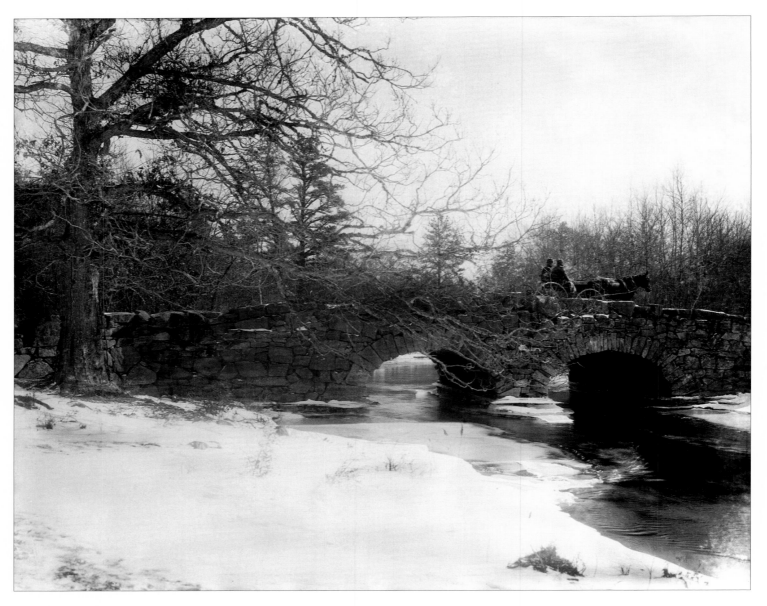

Bridge Across the Paskamansett River in Dartmouth during Winter
Joseph G. Tirrell

Circa 1895
8" x 10" dry plate negative

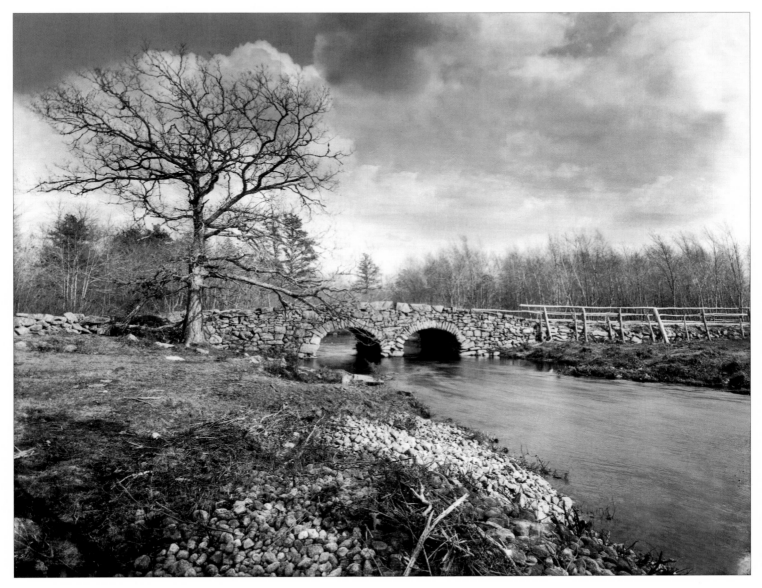

Bridge Across the Paskamansett River in Dartmouth during Spring
Joseph G. Tirrell

Circa 1895
8" x 10" dry plate negative

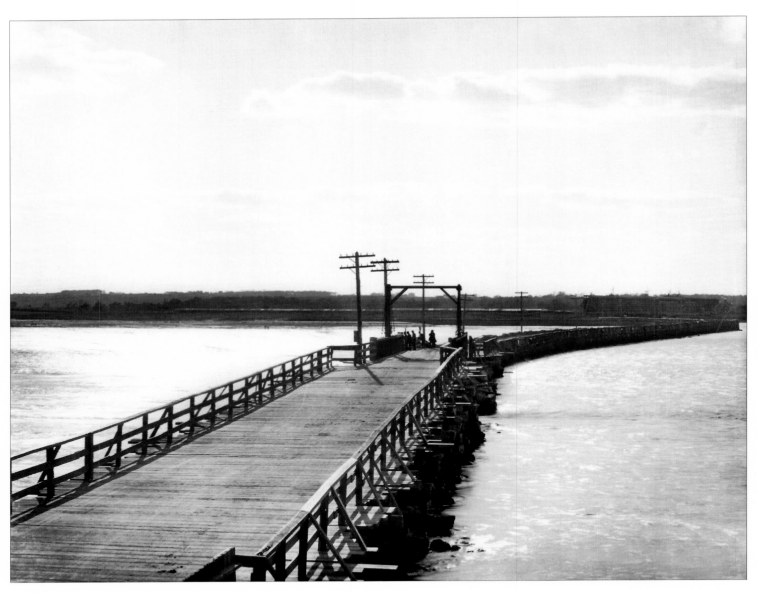

Bridge Across Apponagansett Bay At Padanaram in South Dartmouth
Joseph G. Tirrell

<div style="text-align:right">

Circa 1895
8" x 10" dry plate negative

</div>

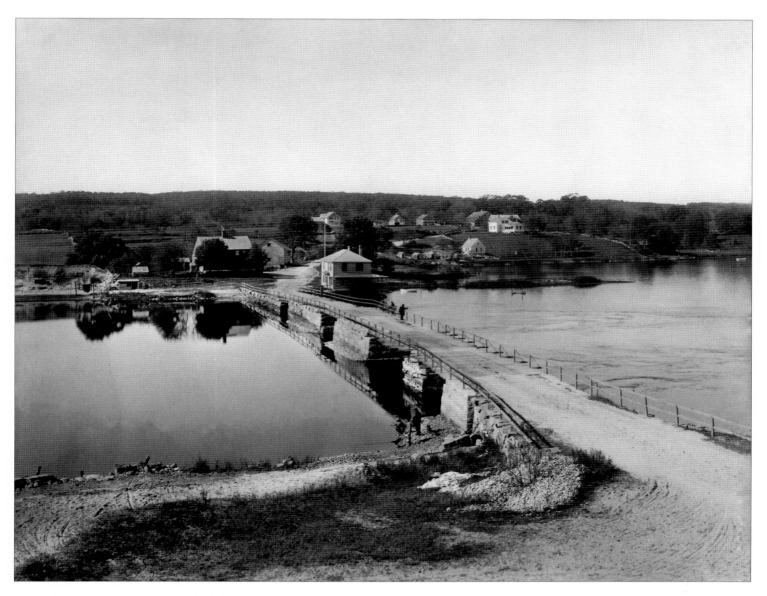

Hix Bridge, Westport, over East Branch of the Westport River
Joseph G. Tirrell

Circa 1895
8" x 10" dry plate negative

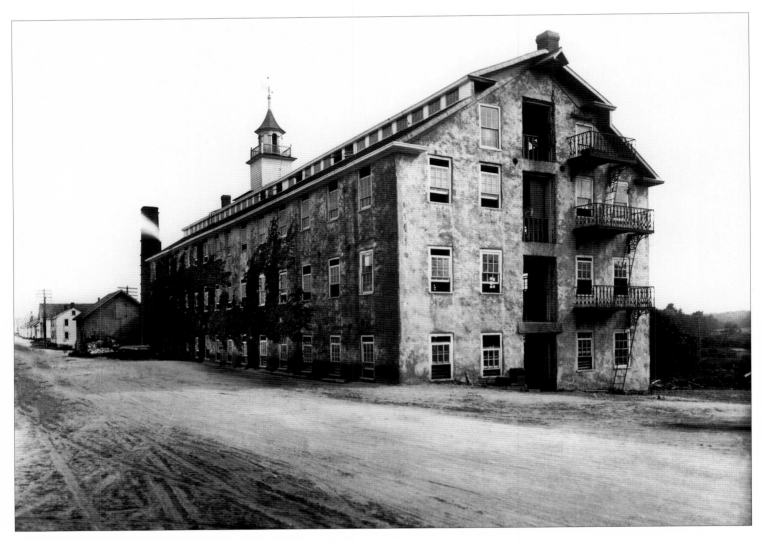

Westport Cotton Manufacturing Company at Westport Factory
Unknown

Circa 1900
6½" x 8½" dry plate negative

Prior to the perfection of the steam engine, rivers and streams were harnessed to run mill machinery. Completed in 1827 at the head of the Westport River's west branch, along State Road, the Westport Cotton Factory drew on the river's power to produce carpet yarn, wicking, twine, warp and cotton batting.

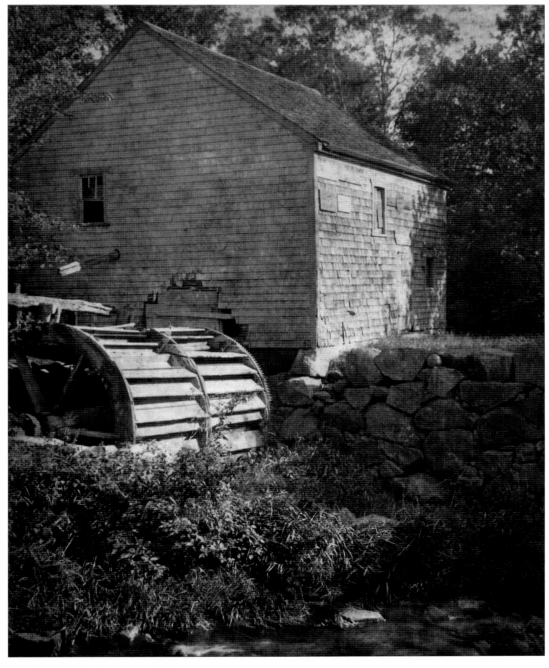

Cummings Mill, Dartmouth 1895
Joseph G. Tirrell 8" x 10" gelatin/silver print

The Cummings Grist Mill was located in the village of Russell's Mills and powered by the Paskamansett River. By the 1890s, when photographed by Tirrell, the mill was no longer in use.

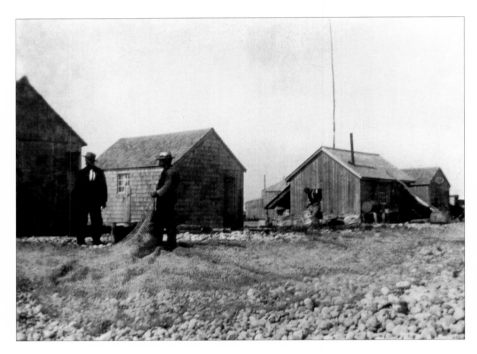

Fishermen's Shacks, East Beach, Westport
Circa 1895

Unknown
3¾" x 4¾" albumen print

Harvesting Hay, Dartmouth
Gifford Collection, Circa 1885

Unknown
4¾" x 6¾" albumen print

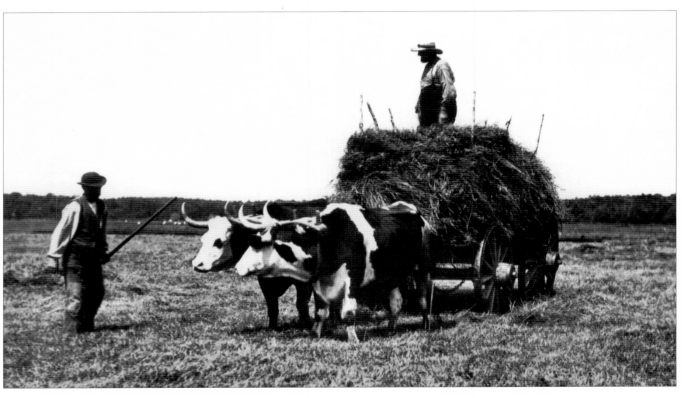

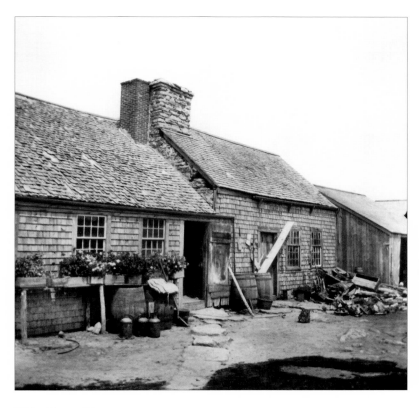

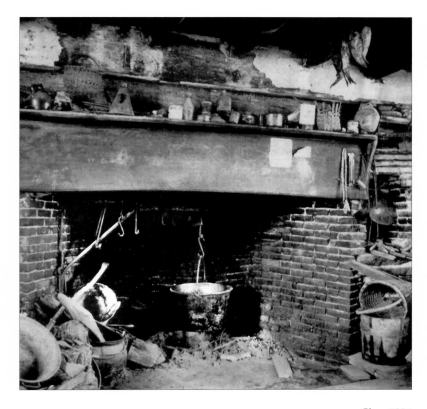

Waite House, Westport
Fred Palmer

Circa 1905
3½" x 3½" nitrate roll film

The team of historian Henry B. Worth and photographer Fred Palmer sought out the most significant old homes to record their histories and appearances. Tradition states that Thomas Waite built this house in 1677, the year after King Philip's War, about a half mile north of Central Village. Design and construction details were recorded in Worth's survey of 1907. At that time, the occupant, Perry C. Potter was living in the new section (with the brick chimney) and using the older part for a hen house and pig sty.

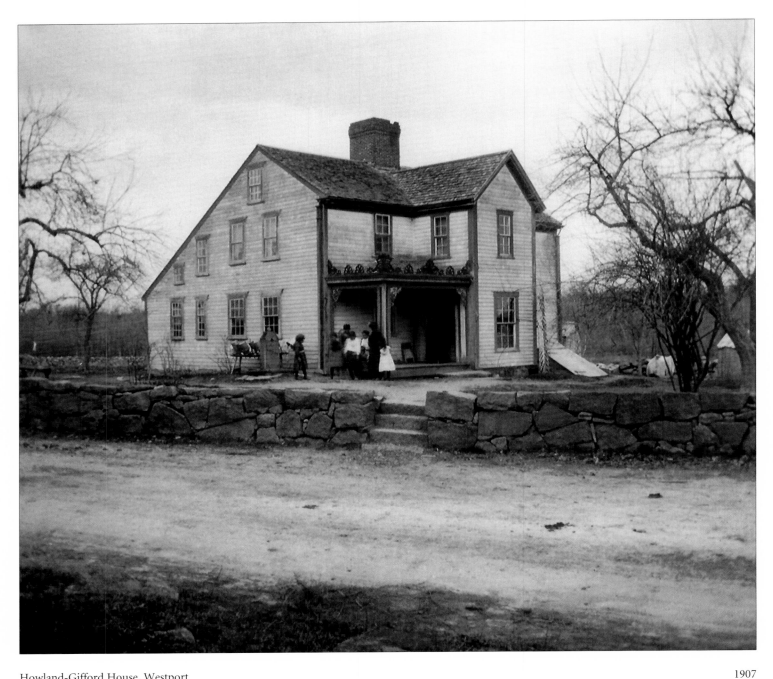

Howland-Gifford House, Westport
Fred Palmer

1907
3½" x 3½" nitrate roll film

At the time of the photograph, this house, dating back to about 1720, was one of few surviving examples of the lean-to design in Old Dartmouth. Henry Worth found it of interest for its remarkable system of windows on the west side.

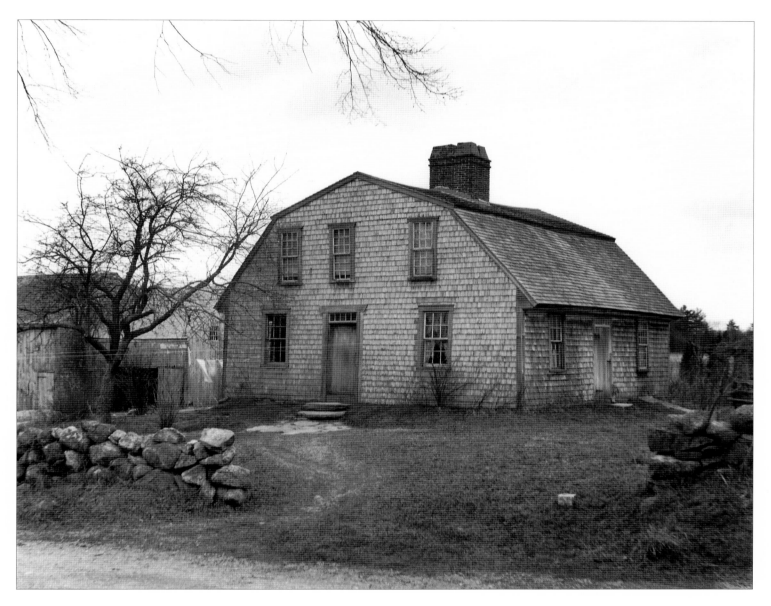

Summerton House, Acushnet
Fred Palmer

1906
4" x 5" dry plate negative

Built by the Reverend Samuel Hunt about 1711, this house stood just east of the bridge at the head of the Acushnet River. Henry Worth believed this to be the earliest example of a gambrel-roof house in the area.

Leisure

*I*n the nineteenth century recreational activities came into their own. In the seventeenth and eighteenth centuries, a preoccupation with basic survival made anything less than work from dawn to dusk unthinkable. As an exception, Sundays were reserved for rest and religion. With the establishment of cities and towns, and the structured week of an industrial society, people used what little leisure time they had to enjoy the countryside, the sea and family gatherings.

As New Bedford prospered, many people became more wealthy. A few individuals amassed huge fortunes and indulged themselves with yachts and summer homes. Ferry excursions to the neighboring islands, picnics, parades, yachting, swimming, sport fishing and photography all found favor in the latter part of the nineteenth century.

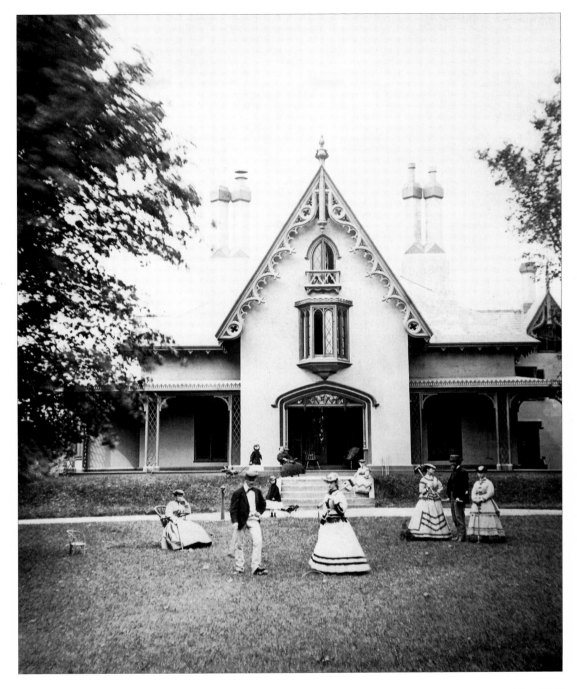

Croquet at Rotch's
Thomas E. M. White

Circa 1870
8" x 10" albumen print

Family and friends socialize during croquet on the manicured grounds of William J. Rotch's Gothic revival cottage.

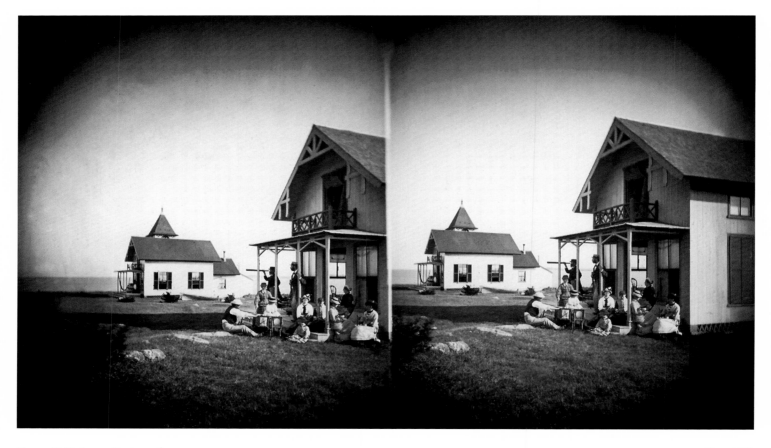

Nonquitt Cottages, Dartmouth
Thomas E. M. White

Circa 1875
5" x 8" stereo wet plate negative

The first dwellings at the summer recreational colony of Nonquitt were tents. Small cottages were in vogue by the 1870s, some with towers and ornate designs, all with porches. In this view are family and friends of artist R. Swain Gifford, who is scanning Buzzards Bay with a telescope.

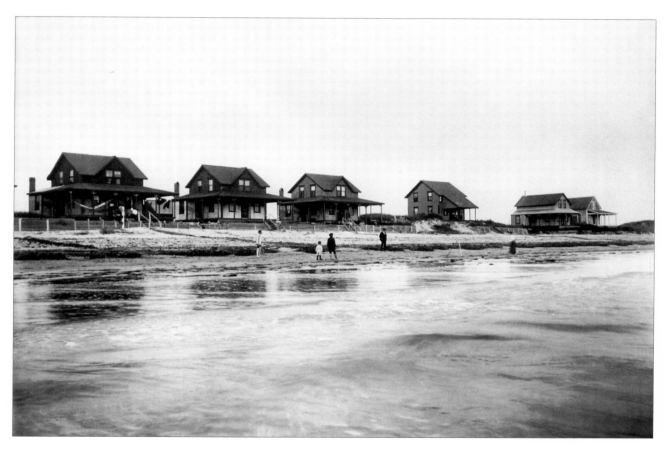

Summer Homes at Horseneck Beach, Westport 1915
Charles Babcock 5" x 7" gelatin/silver print

Horseneck Beach was lined with summer homes until the great hurricane of 1938 destroyed nearly all of them.

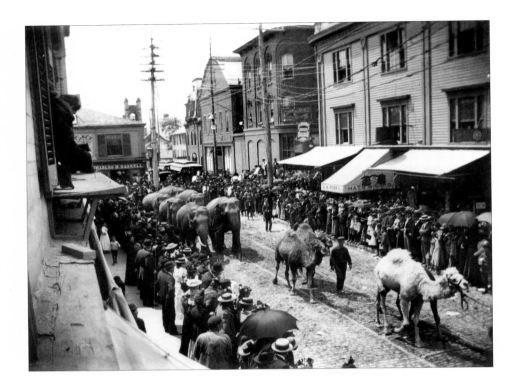

Barnum's Circus Procession, Purchase Street looking South To Union
 Street, New Bedford
Unknown

June 9, 1894
4" x 5" dry plate negatives

One resident recalled that when the procession approached the New
Bedford/Fairhaven bridge, the elephants refused to cross the narrow
wooden draw, perhaps sensing that they might not get across. The
circus turned around, marched through New Bedford, crossed at Head
of the River, and came back through Fairhaven to Popes Island where
the circus was held.

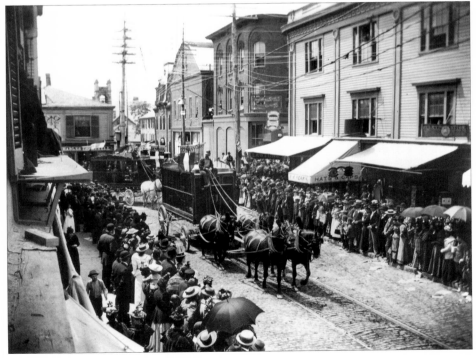

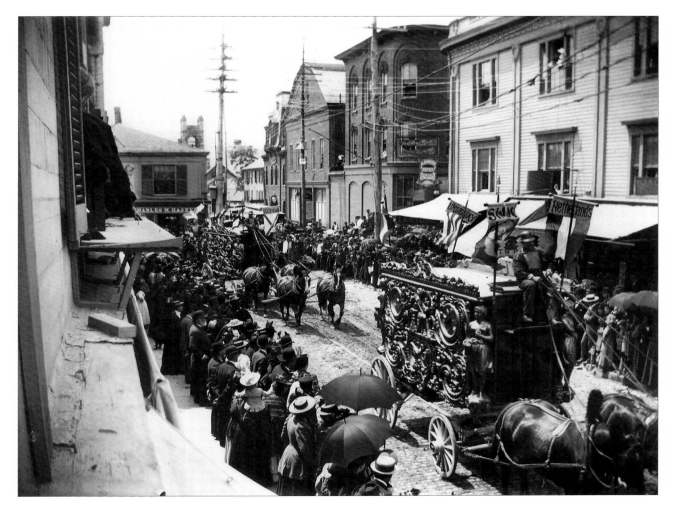

Barnum's Circus Procession
Unknown

June 9, 1894
4" x 5" dry plate negatives

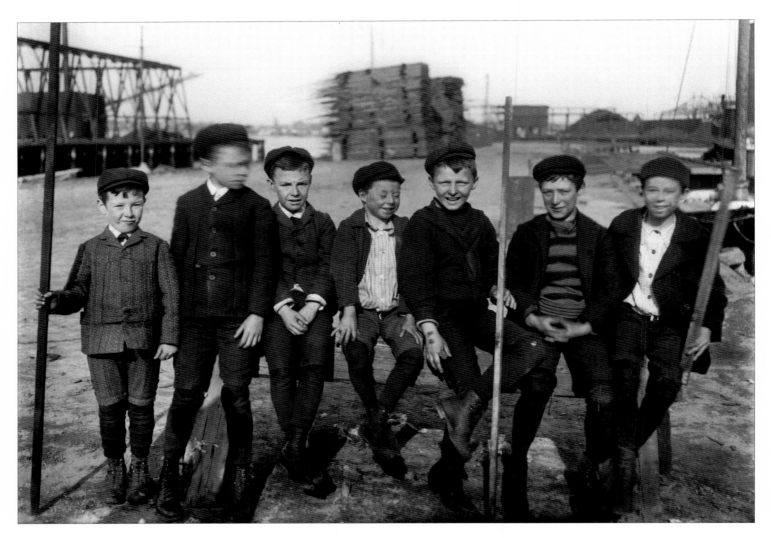

Wharf Rats Circa 1900
Unknown 5" x 7" dry plate negative

For decades, and even centuries, New Bedford's waterfront has been little more than an enormous playground for young boys to explore and be mischievous.

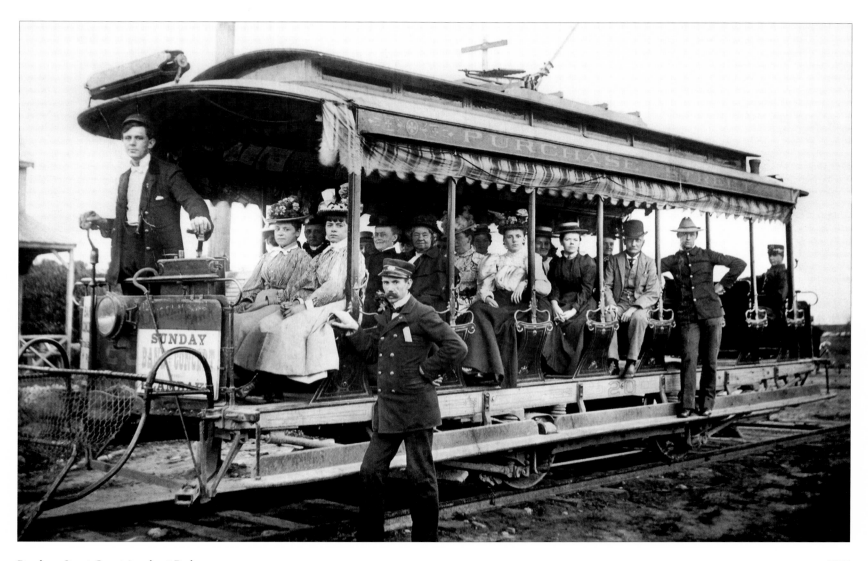

Purchase Street Car at Acushnet Park

E. Paul Tilghman

1897

5" x 7" gelatin/silver printing-out-paper

A network of trolleys served the New Bedford area. In the summer, open-air cars carried passengers to city parks and beaches.

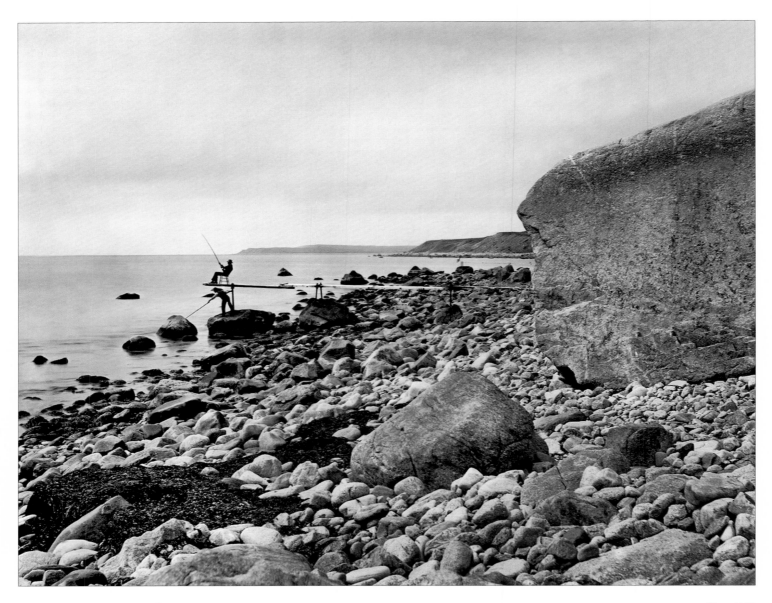

Fishing Stands, Pasque Island
Thomas E. M. White

Circa 1870
8" x 10" wet plate negative

On a trip to the Elizabeth Islands, White photographed members of the Fisherman's Club perched in their fishing stands angling for striped bass.

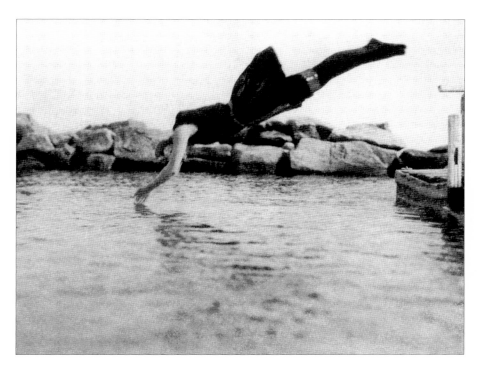

Diver, Prescott Float, Padanaram 1920
Dr. Henry Prescott 4" x 5" cyanotype print

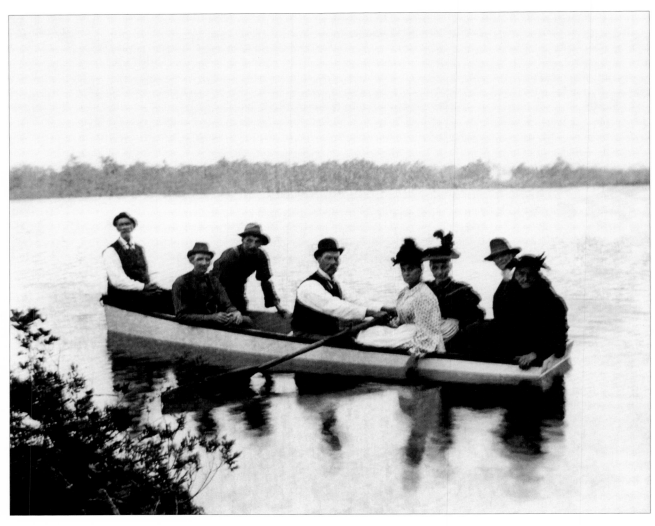

Outing in a Skiff
Charles Babcock

Circa 1910
4" x 5" gelatin/silver print

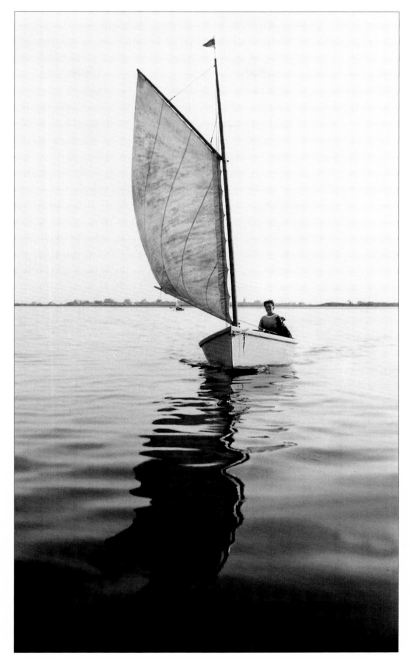

Skiff Debra Doone 1910
Robert R. Wicks 3¼" x 5¾" nitrate negative

Eleanor Hall Wicks pilots her sailing skiff across Westport Harbor. The *Debra Doone*, formerly named *Goldbug,* served as ferry between Lees Wharf and Horse-neck Beach prior to the construction of a bridge.

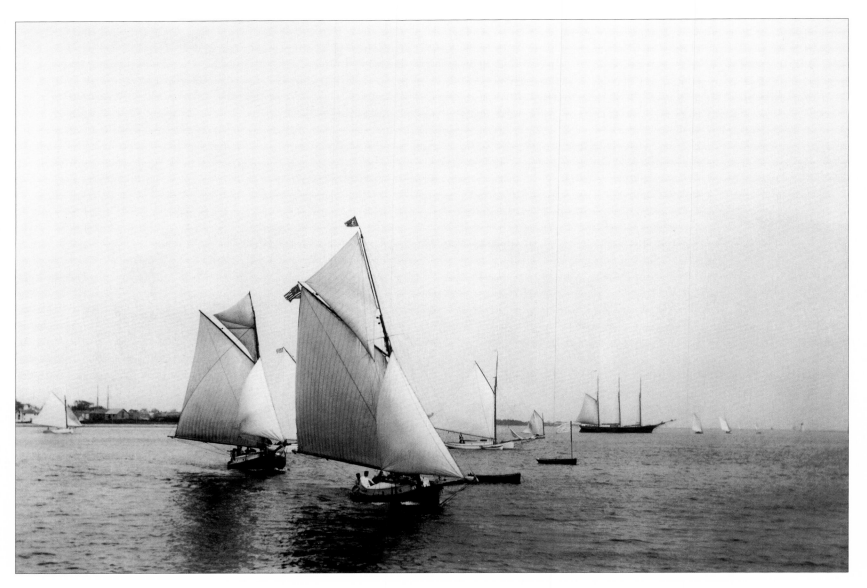

Racing In New Bedford Harbor
James Allen

1886
6" x 8¼" gelatin silver printing-out-paper print

In the 1800s New Bedford Harbor was home to an active yacht club. The fleet in 1886 was composed of five catboats, 15 schooners, and 32 sloops and cutters. Vessels in the sloop/cutter class were similar in design to work vessels known in this port for over 50 years. They sported a plumb stem and a gaff-headed main sail.

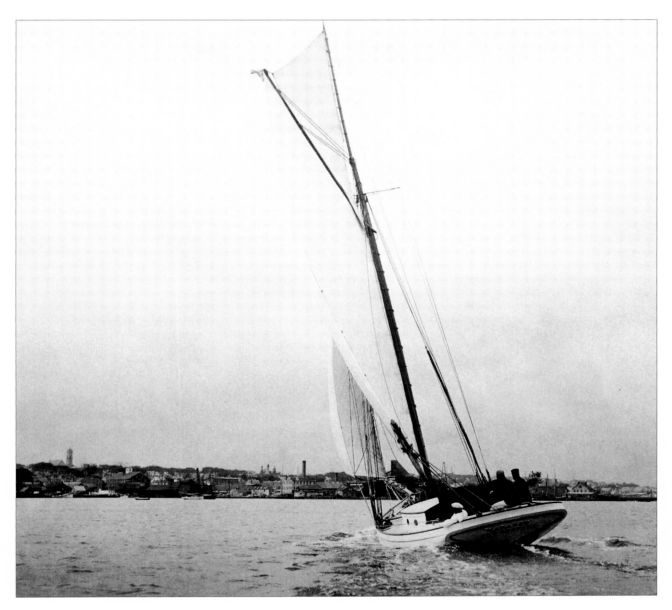

Sloop *Saracen,* New Bedford Harbor
Clifford Baylies

<div align="right">

Circa 1890
7" x 7¼" cyanotype print

</div>

It was difficult to photograph a swiftly moving yacht with a view camera. The crude viewfinders on these cameras made composing approximate at best. Glass plates were individually loaded and exposed in the camera, an operation which could take several minutes, and a yacht would be well out of range before more than a few exposures were made. At least the brightness found on the water permitted high shutter speeds rendering motion frozen.

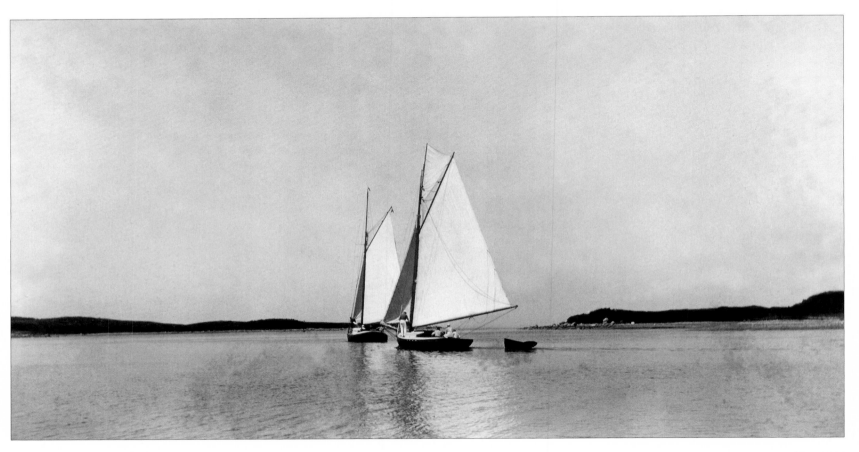

Sloops At Quicks Hole, Elizabeth Islands
James Allen

Circa 1886
5" x 8" gelatin silver printing-out-paper print

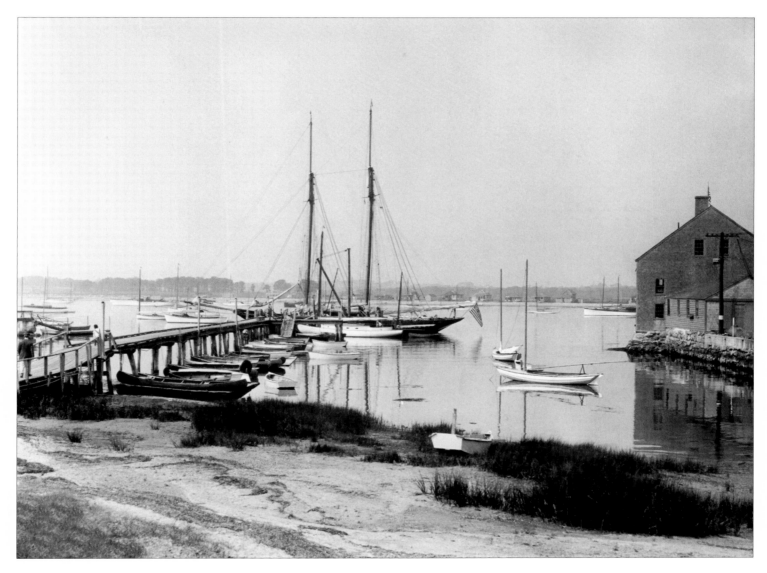

South Wharf, Padanaram
Dr. Henry Prescott

1920
4" x 5" dry plate negative

Tricyclists at Brooklawn Park
Unknown

Circa 1890
5" x 7" dry plate negative

Three Young Photographers
Arnold Wright

Circa 1900
4" x 5" dry plate negative

Photographers Biographic Checklist

Adams, Stephen F.
Born: **1844**
Died: Unknown
Earliest Work 1865
Latest work: 1865
Professional History: Oak Bluffs, before 1865; With Bierstadt Bros. in 1865; Successor to Bierstadt Bros., 39 Purchase St., 1867-1876
Negatives: Wet collodion
Image Type: Albumen, stereograph; 8" x 10", 14" x 17"

Aldrich, Herbert
Born: 1861
Died: March 27, 1948
Earliest Work: Western Arctic, 1887
Professional History: *Evening Standard* writer
Negatives: 4" x 5" dry plate, early use of roll film

Andrews, Frederick W.
Born: New Bedford, May 11, 1845
Died: New Bedford, May 30, 1934
Earliest Work: 1865
Latest Work: 1882
Professional History: Smith & Andrews, 134½ Union St., 1865-70; F. W. & W. F. Andrews, 52 Purchase St., 1871-72; 60½ Purchase St., 1873-78; 68 Purchase St., 1879-82
Negatives: Wet collodion
Image Types: Carte de visite, cabinet card

Allen, James Wood
Born: March 11, 1859
Died: New Bedford, March 16, 1940
Earliest Work: 1886
Latest Work: 1889
Professional History: Amateur
Negatives: Dry plate, 5" x 8", 6" x 8 "
Image Types: Gelatin, printing-out-paper

Ashley, Clifford W.
Born: New Bedford, December 18, 1881
Died: Westport, September 18, 1947
Earliest Work: Unknown
Latest Work: Unknown
Professional History: Amateur
Negatives: 4" x 5" roll film
Image Types: Gelatin/silver print

Ashley, Edmund D.
Born: Milford, 1873
Died: New Bedford, July 5, 1936
Earliest Work: 1891
Latest Work: 1934
Professional History: Swain School of Design graduate in freehand drawing, 1891; Sketch artist and photographer for the New Bedford *Evening Standard* beginning 1892 (photographs were regularly published throughout the 1890s); Listed as photographer in the New Bedford City Directory in 1921-22; Opened studio at 575 Pleasant St. in New Bedford in 1926
Negatives: 4" x 5" dry plate
Image Types: Gelatin/silver

Babcock, Charles Gifford
Born: October 1875
Died: Fall River, February 12, 1967
Earliest Work: Unknown
Latest Work: Unknown
Professional History: Westport, Circa 1900
Negatives: 5" x 7" dry plate
Image Types: Gelatin/silver

Baylies, Clifford
Born: New Bedford, April 27, 1852
Died: New Bedford, July 24, 1924
Earliest Work: 1885
Latest Work: 1915
Professional History: Amateur
Negatives: Dry plate; 5" x 7", 5" x 8", 6" x 8 "
Image Types: Cyanotype, gelatin/silver

Bierstadt, Charles
Born: Dusseldorf, Germany, 1819
Died: Niagra Falls, NY, 1903
Earliest Work: 1859
Latest Work: 1867
Professional History: With brother Edward, 39 Purchase St., 1859-67
Negatives: Wet collodion
Image Types: Carte de visite, stereograph, 8" x 10" and 14" x 17" albumen

Bierstadt, Edward
 Born: Dusseldorf, Germany, 1824
 Died: New York City, Circa 1907
 Earliest Work: 1859
 Latest Work: 1867
 Professional History: With brother Charles, at 39 Purchase St., 1859-67; New York City, 1861; Civil War battlefields with brother Albert Bierstadt, 1862-64; Washington, DC, 1865
 Negatives: Wet collodion
 Image Types: Carte de visite, stereograph, 8" x 10" and 14" x 17" albumen; In New York, used photomechanical *albertypes*

Bradford, William
 Born: Fairhaven, April 30, 1823
 Died: New York, April 25,1892
 Earliest Work: 1869 voyage with John Dunmore & George Critcherson
 Latest Work: Unknown
 Professional History: Unknown
 Negatives: Wet collodion
 Image Types: Albumen; presented in albums or mounted

Bryant, Philander
 Born: Unknown
 Died: Unknown
 Earliest Work: 1841
 Latest Work: Unknown
 Professional History: 57 Union St., 1841
 Image Types: Daguerreotype

Church, Albert Cook
 Born: New Bedford, January 8, 1880
 Died: New Bedford or Fairhaven, February 9, 1965
 Earliest Work: 1917
 Latest Work: 1940s
 Professional History: Pierce & Kilburn Yard
 Negatives: Dry plate, roll film
 Image Types: Gelatin/silver

Comer, Captain George
 Born: Quebec, April 22, 1858
 Died: Northampton, April 27, 1937
 Earliest Work: 1895-1906 Hudson Bay, of Eskimos, taken aboard *Era*
 Latest Work: 1906
 Professional History: Amateur
 Negatives: 4" x 5" dry plate, possibly roll film
 Image Types: Gelatin/silver, 4" x 5"

Doane, Robert
 Born: October 2, 1836
 Died: Unknown
 Earliest Work: 1865
 Latest Work: 1898
 Professional History: With Howland & Crowell, 30 Purchase St., 1865; Doane & Pierce, 30 Purchase St., 1871-72; Doane, 30 Purchase St., 1873-78; 36 Purchase St., 1879-87; 54 Purchase St., 1890-98
 Negatives: Wet collodion, dry plate
 Image Types: Albumen, carte de visite, cabinet card, gelatin, printing-out-paper

Dunshee, E. S.
 Born: Unknown
 Died: Unknown
 Earliest Work: 1859
 Latest Work: Unknown
 Professional History: 30 Purchase St., 1859
 Negatives: Wet collodion
 Image Types: Ambrotype, carte de visite

Fales, Charles
 Born: Unknown
 Died: Unknown
 Earliest Work: 1849
 Latest Work: 1865
 Professional History: 22 Cheapside, 1849; 62 Purchase St. with Lemuel Taber, 1853; 62 Purchase St., 1856; 64 Purchase St., 1859; 64 Purchase St., with Thomas Mayo, 1865
 Image Types: Daguerreotype, ambrotype

Hawes, Charles
 Born: Unknown
 Died: Unknown
 Earliest Work: 1843
 Latest Work: 1859
 Professional History: 105 Union St., 1845; Liberty Hall, New Bedford, 1849-52; 50 Purchase St., with Ira Negus, 1856; 50 Purchase St., alone, 1859
 Image Types: Daguerreotype, ambrotype

Howard, James S.
 Born: Acushnet, 1840
 Died: New Bedford, January 27,1913
 Earliest Work: 1865
 Latest Work: 1874
 Professional History: 19 Purchase St., alone from 1865-67 and 1872-74; 19 Purchase St. with E. Howard, 1867-72
 Negatives: Wet collodion
 Image Types: Albumen

Jenney, Benjamin Frank
> **Born:** Unknown
> **Died:** Unknown
> **Earliest Work:** 1862
> **Latest Work:** 1884
> **Professional History:** Jenny & Ward, 52 Purchase St., 1862-65; Jenny & Smith, 52 Purchase St., 1865-70; 47 School St., 1871-72; 134 Union St., 1873-74; 47 School St., 1877-78; 5 Purchase St., 1881-82; 25 Purchase St., 1883-4
> **Negatives:** Wet collodion
> **Image Types:** Carte de visite, cabinet card

Jordan, C. S.
> **Born:** Unknown
> **Died:** Unknown
> **Earliest Work:** 1847
> **Latest Work:** Unknown
> **Professional History:** 12 Purchase St.
> **Image Types:** Daguerreotype

Killan, Bernard
> **Born:** Springfield, 1893
> **Died:** Still Living
> **Earliest Work:** 1913
> **Latest Work:** 1914 (aboard 1913-14 *Polar Bear* voyage)
> **Professional History:** Amateur
> **Negatives:** Roll film
> **Image Types:** Gelatin/silver

Martin, Joseph S.
> **Born:** Newtonville, 1883
> **Died:** New Bedford, February 14, 1947
> **Earliest Work:** 1903
> **Latest Work:** 1945
> **Professional History:** Clerk for Joseph G. Tirrell at 62 Pleasant St., 1902-04; Assistant to Tirrell, 1904-05; Photographer, 62 Pleasant St., 1905-10; 49 William St., 1911-15; 222 Union St., Room 210, 1914-1940
> **Negatives:** 8" x 10" dry plate, 8" x 10" nitrate sheet film
> **Image Types:** Gelatin/silver

Negus, Ira S.
> **Born:** New Bedford, 1840
> **Died:** Unknown
> **Earliest Work:** 1856
> **Latest Work:** 1872
> **Professional History:** Apprentice to Charles Hawes at 50 Purchase St., 1856; With Morris Smith, 134 Union St., 1859; Tallman & Negus, 60 Purchase St., 1865-70; Alone at 60 Purchase St., 1871-72
> **Image Types:** Ambrotype

O'Brien & Faxon
> **Born:** Unknown
> **Died:** Unknown
> **Earliest Work:** 1841
> **Latest Work:** Unknown
> **Professional History:** Itinerant
> **Image Types:** Daguerreotype

O'Neil, John
> **Born:** Unknown
> **Died:** Unknown
> **Earliest Work:** 1887
> **Latest Work:** 1907
> **Professional History:** 88 Purchase St., 1887-1907; O'Neil Studio, Purchase St., 1908-09
> **Negatives:** Dry plate
> **Image Types:** Cabinet card

Packard, Arthur F.
> **Born:** South Braintree, 1881
> **Died:** Fairhaven, 1972
> **Earliest Work:** 1916
> **Latest Work:** 1950
> **Professional History:** Freelance photographer, 1914-16; Fall River *Globe*, New Bedford *Evening Standard* and *Standard-Times*, 1920-50
> **Negatives:** 6" x 8" dry plate
> **Image Types:** Gelatin/silver

Parlow, George F.
> **Born:** Unknown
> **Died:** Unknown
> **Earliest Work:** 1854
> **Latest Work:** 1887
> **Professional History:** With E. S. Dunshee, 30 Purchase St., 1854; 5 Purchase St., 1854-87; With Noah Gifford & David W. Wilson, 1869-70; Tampa, FL, 1898; Retired in 1902
> **Negatives:** Wet collodion, dry plate
> **Image Types:** Ambrotype, carte de visite, cabinet card, stereograph, 8" x 10" prints

Reed, James Edward
> **Born:** Winston, NC, January 31, 1864
> **Died:** New Bedford, September 17, 1939
> **Earliest Work:** 1888
> **Latest Work:** 1934
> **Professional History:** Headley & Reed, 5 Purchase St., 1888-1895; 5 Purchase St., 1896-91; 7 Purchase St., 1902-14; Massachusetts State House photostat operator, 1914-34
> **Negatives:** Dry plate
> **Image Types:** Cabinet card, 5" x 7"

Sherman, Francis P.
 Born: Unknown
 Died: Unknown
 Earliest Work: 1877
 Latest Work: 1925
 Professional History: With Morris Smith, 134 Purchase St., 1877-85; 174 Union St., 1887-94; 74 Purchase St., 1895-1912; 844 Purchase St., 1913-25
 Negatives: Dry plate
 Image Types: Cabinet card

Smith, Morris
 Born: Walpole
 Died: Unknown
 Earliest Work: 1849
 Latest Work: 1885
 Professional History: 134½ Union St., 1849-85; With Ira S. Negus, 1859; With Frederick W. Andrews, 1869-70; With H. W. Smith, 1871-72; With Francis P. Sherman, 1877-85
 Negatives: Wet collodion
 Image Types: Daguerreotype, carte de visite, cabinet card

Taber, Charles & Co.
 Born: Unknown
 Died: 1887 (Charles)
 Earliest Work: 1859
 Latest Work: 1896
 Professional History: 6 North Water St., 1859- 96; With Henry Gifford, Joseph Tirrell, Asa Pierce, Frank Pope, 1865; With Nelson Wood, 1867-68; With Leonard Bushnell, C. Taber, Frank Bly, J. Tirrell, H. Gifford, N. Wood, and Luther Hate, 1869-70
 Note: Charles Taber Co. employed the group listed above as technicians producing a large volume of art reproduction and copy work.
 Negatives: Wet collodion, dry plate
 Image Types: Ambrotype, carte de visite, cabinet card, photomechanical art reproductions

Taber, Lemuel W.
 Born: 1825
 Died: Unknown
 Earliest Work: 1852
 Latest Work: 1874
 Professional History: With Charles Fales, 62 Purchase St., 1852; 58 William St., 1856; 97 Union St., 1859; 6 Walnut St., 1865; Cheapside and William St., 1867- 68; 114 South Water St., 1869-70; 16 Middle St., 1871-74
 Negatives: Wet collodion
 Image Types: Ambrotype, tintype, carte de visite

Tallman, Edward G.
 Born: Unknown
 Died: Unknown
 Earliest Work: 1865
 Latest Work: 1870
 Professional History: 60 Purchase St., 1865; Tallman & Negus, 60 Purchase St., 1867-70
 Negatives: Wet collodion
 Image Types: Ambrotype, carte de visite

Tilghman, Eugene Paul
 Born: New Bedford, June 13, 1858
 Died: December 23, 1909
 Earliest Work: Unknown
 Latest Work: Unknown
 Professional History: Carriage Washer from 1879-82; 163 William St., 1902-09
 Note: Tilghman was one of only two known black photographers in New Bedford
 Negatives: 5" x 7" dry plate
 Image Types: Gelatin/silver

Tirrell, Joseph G.
 Born: New Bedford, 1840
 Died: New Bedford, September 14, 1907
 Earliest Work: 1865
 Latest Work: 1907
 Professional History: Charles Taber & Co., 6 North Water St., 1865-98; 62 Pleasant St., 1899-1907
 Negatives: 8" x 10" dry plate
 Image Types: Gelatin/silver

Index

Selected Bibliography

NEWSPAPERS

Boston *Atlas*. Boston MA. 1840.
Evening Standard. New Bedford MA. 1850-1930.
Fairhaven Star. 1879-1930.
Morning Mercury. New Bedford MA. 1841-1930.
Times. New Bedford MA. 1902-1930.
Whaleman's Shipping List and Merchant's Transcript. New Bedford 1843-1914. Collection of the New Bedford Free Public Library.

PUBLISHED SOURCES

Aldrich, Herbert. 1889. *Arctic Alaska and Siberia, or, Eight Months with the Arctic Whalemen*. Chicago: Rand-McNally.

Allen, Everett S. 1973. *Children of the Light: The Rise and Fall of New Bedford Whaling and the Death of the Arctic Fleet*. Boston: Little, Brown & Co.

Atlas of New Bedford City, Massachusetts. 1881. Boston: George H. Walker & Co.

Blasdale, Mary Jean. 1990. *Artists of New Bedford*. New Bedford: Old Dartmouth Historical Society.

Bockstoce, John R. 1977. *Steam Whaling in the Western Arctic*. New Bedford: Old Dartmouth Historical Society.

Bockstoce, John R. 1986. *Whales, Ice and Men*. Seattle and London: University of Washington Press.

Boss, Judith A. and Joseph D. Thomas. 1983. *New Bedford: A Pictorial History*. Norfolk: Donning Co.

Bradford, William. 1873. *The Arctic Regions*. Photographic album. London: Sampson, Low, Marston, Low, and Searle.

Earl, Edward W. 1979. *Points of View: The Stereograph in America-A Cultural History*. Rochester: Visual Studies Workshop Press

Ellis, Leonard Bolles. 1892. *History of New Bedford and Its Vicinity, 1602-1892*. New York, Syracuse: D. Mason & Co.

Hall, Elton. 1982. *Sperm Whaling From New Bedford: Clifford W. Ashley's Photographs of Bark Sunbeam*. New Bedford: Old Dartmouth Historical Society.

Howland, Waldo. 1984. *A Life in Boats: The Years Before the War*. Mystic: Mystic Seaport Museum.

Huse, Donna and Joseph D. Thomas. 1980. *Spinner: People and Culture in Southeastern Massachusetts, Vol. I*. New Bedford: Spinner Publications.

——. 1981. *Spinner: People and Culture in Southeastern Massachusetts, Vol. II*. New Bedford: Spinner Publications.

——. 1984. *Spinner: People and Culture in Southeastern Massachusetts, Vol. III*. New Bedford: Spinner Publications.

Kugler, Richard. 1975. *New Bedford and Old Dartmouth: A Portrait of a Region's Past*. New Bedford: Old Dartmouth Historical Society.

Morison, Samuel Eliot. 1921. *The Maritime History of Massachusetts. 1783-1860*. Reprint. Boston: Northeastern University Press.

Naef, Weston. 1975. *Era of Exploration*. New York: Albright-Knox Art Gallery.

New Bedford Bi-Centennial Commemorative Calendar, 1787-1987. New Bedford: Spinner Publications.

New Bedford City Directory 1841-1925.

Newhall, Beaumont. 1976. *The Daguerreotype in America*. New York: Dover.

Newhall, Beaumont. 1964. *The History of Photography*. New York: New York Graphic Society.

Pease, Zephaniah W. 1918. *History of New Bedford*. New York: Lewis Historical Publishing Co.

Pease, Zephaniah W. 1907. *100th Anniversary of the New Bedford Mercury*. New Bedford.

Rosenbloom, Walter and Alan Trachtenberg. 1977. *America and Lewis Hine*. New York: Apperture.

Shute, Charles. 1868. *A Whaling Voyage*. Edgartown: Charles H. Shute & Son

Thomas, Joseph D., 1986. *Spinner: People and Culture in Southeastern Massachusetts, Vol. IV*. New Bedford: Spinner Publications.

Weinstein, Robert A. and Larry Booth. 1977. *Collection, Use, and Care of Historical Photographs*. Nashville: American Association for State and Local History.

Welling, William. 1976. *Collectors Guide to Nineteenth Century Photographs*. 1976. New York: Macmillan Publishing Co., Inc.

William Whitman Company, Inc. 1921. *Wool and Cotton in All Forms from Yarn to Fabric*. New York.

UNPUBLISHED SOURCES

Crapo, Henry Howland. 1937. "The Story of Cotton and Its Manufacture into Cloth in New Bedford." *New Bedford: Old Dartmouth Historical Sketches*, No. 67.

Worth, Henry B. 1905. *Photographs of Old Dartmouth*. New Bedford Public Library and Old Dartmouth Historical Society.

Spinner Publications, Inc. is a nonprofit, community-based small press which seeks to record the history and culture of the cities and towns of southeastern Massachusetts. Spinner books employ oral history, photography, narrative prose and firsthand accounts to tell the story of the individual, the community and working the land. Studying family and community history brings history to a personal level and allows us to see how people have established homes, earned a living and participated in culture, all within a shaping context of geography, urbanization and industrialism. Understanding history is essential in adjusting to current changes and making our way into the future. Spinner would like to contribute to this understanding by recording history in a way that is accessible to many people, to show how people's lives have impacted the community and the region, and to arouse a sense in the public that their history is important and will be told if they tell it. If you are interested in knowing more about Spinner Publications and our books in print, or in contributing to the Spinner archives and our community programming efforts, such as the New Bedford Textile Museum, please call or write:

Spinner Publications · P.O. Box 1801 · New Bedford, MA 02741 · (508) 994-4564